Creative Chicago *An Interview Marathon*

Hans Ulrich Obrist & **Alison Cuddy**
with Tim Samuelson *and* Eve L. Ewing
and Joseph Grigely *and* Gerald Williams,
Suellen Rocca & Art Green *and* Stanley
Tigerman *and* Richard Hunt *and* Barbara
Kasten & Jeanne Gang *and* Edra Soto &
Fatimah Asghar *and* Louise Bernard &
Theaster Gates *and* Dawoud Bey *and* Shani
Crowe & Eddie Bocanegra *and* Amanda
Williams & Eula Biss *and* Cauleen Smith &
Brandon Breaux *and* Dominick Di Meo

Terra Foundation for American Art Chicago | Paris
Distributed by University of Chicago Press

Post-it Note, Stanley Tigerman.

Creative Chicago:
An Interview Marathon with Hans Ulrich Obrist
September 29, 2018
Navy Pier, Chicago

Produced by the Chicago Humanities Festival, *Creative Chicago: An Interview Marathon with Hans Ulrich Obrist* was a five-hour series of conversations with artists, authors, architects, and others representing Chicago's diverse creative community. The event took place Saturday, September 29, 2018 on a stage designed by renowned artist Barbara Kasten in the Aon Grand Ballroom at Chicago's Navy Pier as part of the city's annual international art exposition, EXPO CHICAGO. It was presented free and open to the public.

The interviews were conducted by Hans Ulrich Obrist—artistic director of the Serpentine Galleries in London and an influential international curator and critic known for his long-form dynamic interview practice. *Creative Chicago* was Obrist's first interview marathon in the United States and took a multidimensional, multidisciplinary look at creativity in the city, past, present, and future. Through this wide-ranging series of dialogues, *Creative Chicago* explored the many artistic and institutional forces that have made and continue to make Chicago a creative powerhouse.

Creative Chicago: An Interview Marathon was funded in part by the Terra Foundation for American Art with The Richard H. Driehaus Foundation. It was a centerpiece program of the Terra Foundation's citywide initiative, Art Design Chicago, exploring the city's art and design history through exhibitions and events in 2018, as well as a number of publications. Additional support for the *Creative Chicago* event was provided by Elizabeth A. Liebman, Herman Miller, Make It Better, and *Surface* magazine.

An initiative of the Terra Foundation for American Art exploring Chicago's art and design legacy.

Presenting Partner

oh gosh

Post-it Note, Eve L. Ewing.

The Post-it Notes throughout this publication were created by *Creative Chicago* interviewees as part of an ongoing project started by Hans Ulrich Obrist at the encouragement of Etel Adnan and Umberto Eco. With the goal of preserving handwriting and doodles, Obrist has collected almost four thousand notes to date, which he posts to Instagram @hansulrichobrist.

Post-it Note, Eula Biss.

Foreword

Elizabeth Glassman
*President and Chief
Executive Officer,
Terra Foundation for
American Art*

At the Terra Foundation for American Art, we believe art has the potential both to distinguish cultures and to unite them. International curator Hans Ulrich Obrist's interview project provides indisputable proof of that concept. His practice over many years of conducting long-form interviews with artists around the world, and making those conversations widely available, has advanced the exchange of ideas and demonstrated the power of creative expression. That's why, when the Terra Foundation embarked on Art Design Chicago, a deep exploration of Chicago's art and design history and legacy, we dreamed of involving Hans Ulrich Obrist, and were thrilled when he proposed holding his first US-based interview marathon in Chicago, in conjunction with the initiative. We knew that he, like no one else, could elicit compelling insights about the city and its creative production.

The first large-scale exploration of Chicago's art and design history to date, Art Design Chicago was a spirited celebration of the unique and vital role Chicago plays as America's crossroads of creativity and commerce. Initiated by the Terra Foundation for American Art with, as Presenting Partner, The Richard H. Driehaus Foundation, this citywide partnership of ninety-five-plus cultural organizations examined Chicago's distinct creative legacy through exhibitions and public and academic programs throughout 2018, as well as several new publications.

Yet even as we looked back at the creative history of Chicago, we recognized the importance of connecting the past to the present. A centerpiece event of Art Design Chicago, *Creative Chicago: An Interview Marathon* explored the contemporary creative ecosystem in Chicago that is the legacy of the thousands of artists and designers who have made the city a hub for innovation since its earliest days.

On September 29, 2018, Hans Ulrich Obrist brought his infectious energy and masterful interviewing skills to a dialogue with twenty-one current and former Chicagoans—artists, authors, architects, performers, and others—who reflected on their practices and talked about their contributions to the city, the influence of its past and people on their work, and their ideas about what Chicago needs next to build a better future for all.

We are proud to have supported *Creative Chicago: An Interview Marathon*, and we thank Hans Ulrich Obrist for bringing his remarkable vision to Chicago. We are tremendously grateful to the Chicago Humanities Festival, especially Marilynn Thoma Artistic Director Alison Cuddy and Executive Director Phillip Bahar, for their willingness to embark on this adventure and ability to manage the marathon with creativity, sensitivity, and sophistication. We are also very appreciative of our hosts, Tony Karman and Stephanie Cristello at EXPO CHICAGO and Michelle Boone at Navy Pier, for their generous partnership and hospitality.

For an afternoon, *Creative Chicago: An Interview Marathon* united a diverse group of individuals in a series of conversations that together formed a distinctive snapshot of Chicago—its strengths, its challenges, and its potential. It was an event to remember, and we're pleased to preserve its essence and share it with a larger audience in this publication. We hope this record of that extraordinary day will spark new curiosity about our city's artistic past and present, and foster continued dialogue about Chicago's future.

Introduction

Alison Cuddy
Marilynn Thoma
Artistic Director, Chicago
Humanities Festival

Creative Chicago: An Interview Marathon was a beautifully expansive answer—or at least the beginning of one—to a question once posed by the creator of the longstanding marathon project, Hans Ulrich Obrist: "What would a city made and run by artists look like?"

Artists are the not-so-secret backbone of Chicago, and the event staged at Navy Pier on September 29, 2018—Obrist's first marathon to focus on the creativity of a specific city—excavated how vital their work is to the constant renewal of our metropolis. Over the course of five hours, more than twenty architects, curators, designers, musicians, painters, photographers, and writers—some long established, some just emerging—displayed their intellect and curiosity, while detailing their work and the complex processes behind it: from materials testing and prototyping to deep research and investigations almost ethnographic in their detail.

Like our builders and engineers, Chicago artists work to fabricate the city, but their approach provides a subtle perspective on its citizens' differing needs and desires. Artists possess a sense of the big picture, the whole *and* its parts, the ways we do and do not work together, and the possibilities we've yet to realize. They invent worlds that may never be realized in real life but nonetheless capture how we live and what we think of one another, the deep drama of everyday life.

Structurally, the marathon was very much inspired by Chicago's flair for the theatrical—evident not only in our robust theater scene but in our endless political angst, our dramatic location on the edge of Lake Michigan, and the sudden shifts in style, tone, and temperament that distinguish one neighborhood from the next. The setting—a stunning historic space inspired by one of the city's early visionaries, the nineteenth-century architect Daniel

Burnham, with a beautiful stage constructed by a contemporary visionary, conceptual artist Barbara Kasten—worked as a physical manifestation of the stream of conversation: multidimensional, cross-disciplinary, transparent, reflective.

The four "Acts" of the marathon—Prologue, Foundations, Building, and Vanguard—form a loose chronology that allows for a sense of the evolution of Chicago's creativity across time and space. At the same time, each Act stands on its own as a kind of prism, providing a view of Chicago's creative past, present, and future simultaneously. Punctuation came in the form of a film screening, a performance, and finally, a musical invocation inspired by the Chicago futurist Sun Ra, whose creative spirit and work is still light years ahead of our present moment. Each of these performances felt aspirational and captured the work of art in progress, not at rest.

All of this served to capture the essentials of Chicago-style creativity, which is driven by an understanding of the importance of place as well as a sense of history, by a robust cross-cultural ferment, and by an ethos mired in what Chicago cultural historian Tim Samuelson describes as a "city that doesn't follow the rules." The cultural infrastructure required to make an artistically driven city sustainable were also made manifest, from influential institutions such as the Art Institute of Chicago to dynamic neighborhood spaces like the Hyde Park Art Center. Though different in mission and scale, each served as a significant formative place for multiple artists in the marathon.

Perhaps most importantly, the marathon made visible gaps or missing elements. In Chicago we pride ourselves on the powerfully collaborative nature of our cultural ecosystem. How, then, do we explain why so many of the participants—renowned in their own fields—were meeting similarly distinguished colleagues from other disciplines for the very first time? To realize, for example, that members of AfriCOBRA and the Hairy Who—two of city's most innovative and influential artist collectives—had never before crossed paths, speaks volumes about the way artistic and cultural circles have not transcended but rather reflect our city's racial divides and economic disparities.

How to remedy or redress this legacy? One way to start is with what the marathon tried to set in motion: bringing artists who might not otherwise have met together in conversation. By so doing, the event became not just a meditation on creativity in Chicago but an act of creativity itself, one that will spawn many new collaborations, some across historically entrenched barriers. As Amanda Williams said, one of the things Chicago needs is "for everybody to operate outside of their own best self-interest ... to try a little harder." Creativity is in fact a calling to try harder, to aim higher, to dig deeper. Here's hoping that *Creative Chicago: An Interview Marathon* is a blueprint for how to begin.

Creative Chicago
An Interview Marathon

I'm Hans Ulrich Obrist. Actually, I'm not. I'm Mark Kelly, the Commissioner for Cultural Affairs and Special Events for the City of Chicago. On behalf of Mayor Rahm Emanuel, let's give a big hand to the Chicago Humanities Festival, EXPO CHICAGO, and the Terra Foundation for this incredible event. I want to encourage everyone now and then to just look out here. The light on the lake today is stunning—it looks like you can see all the way to Michigan. What a gorgeous setting.

So, let me jump into my riff. Chicago is a cultural powerhouse. But it's a powerhouse that's driven by its dichotomies and tension points: Stinky. Flat. Swampy. Money-hungry. Deeply segregated. Typhoid-infected. Cow town. Insecure. Civil unrest. Factory town. Labor strife. Crime. Pervasive violence. Politicians on the take. Dirty. Social unrest. Deep fissures of wealth and poverty. Conventional. Priggish. Carcasses in the river. Crass. Base. And oh, yeah, police corruption. Good start, huh?

Truth number two: Soaring. Expansive. Utopian. Innovative. Unencumbered. Fresh. Visionary. The embrace of technology and the machine. Idealistic. Unfettered by tradition. Brash. Loud. Devil-may-care. Immigration city. The Great Migration. The Columbian Exposition. City Beautiful. City in a garden. Bronzeville. Pilsen. Dynamically diverse. Commercially alive. Socially committed. Inspired. Imaginative. Big. Spirited.

Mark Kelly
Commissioner, Chicago Department of Cultural Affairs and Special Events

The results of these dichotomies: A hothouse environment fostering impressive ferment and creation. Birthplace of improv and storefront theater. The poetry slam. Spoken word. The skyscraper and the bungalow. A protected lakefront. Great city parks. Incubator of modern jazz. Blues. Gospel and house. Footwork. The Picasso. The Wall of Respect. Pilsen murals. The Imagists. The embrace of the outsider. The Chicago Black Renaissance. Public art. Design center. Great museums. Millennium Park.

And more: Mahalia, Bo, Muddy, and Armstrong shaped the music of the world. Burnham, Sullivan, and Skidmore reached for the sky. Gwendolyn and Studs reached for the soul. Jensen coaxed nature to swoon. Nichols, May, and Belushi delivered wicked laughs, their legacies transformed and carried far beyond our city limits. There have been ebbs and flows in our cultural life, periods of architectural wonder and moments of architectural drivel. But this moment in Chicago is one of our great moments of cultural ferment and creation. New parks, public art, important architecture, a vibrant music scene, Chicago theater, and a compelling arts landscape.

Today we'll hear, framed by Chicago's dichotomies and tension points, the weight of Chicago's cultural legacy. But most importantly we will learn what is next for Chicago, one of the great cultural capitals of the world.

Thank you. Enjoy this great marathon.

Nora Daley
Board Member,
Terra Foundation for
American Art

Thank you, Mark. You've been such a great champion for today's interview marathon from the beginning. We so appreciate your leadership on this project, and the many initiatives you and your team at the Department of Cultural Affairs and Special Events (DCASE) spearhead on a daily basis to ensure that Chicagoans and visitors alike have access to world-class arts and culture.

My name is Nora Daley, and I'm thrilled to be here today to kick off *Creative Chicago*. I'm here wearing multiple hats: as a strong supporter of local arts; as a member of the advisory committee that worked with the Chicago Humanities Festival to shape today's interview marathon; as a board member of the Terra Foundation for American Art, the lead supporter of today's event; and

as a civic committee member of Art Design Chicago, which is an initiative of the Terra Foundation.

Art Design Chicago is an immense, collective exploration and celebration of this city's rich art and design legacy. Through more than thirty exhibitions and hundreds of events, as well as scholarly programs and publications, Chicagoans and visitors to this great city are discovering a wealth of new stories about Chicago's dynamic history as a crossroads of creativity and commerce.

Creative Chicago is a centerpiece of Art Design Chicago, and one that the Terra Foundation is very proud to support. What's really beautiful about this program is that over the course of these next hours, a new picture of Chicago's creative legacy and future will emerge. We see this as a historic moment, and we're so glad you all came to join us.

We look forward to welcoming Hans Ulrich Obrist to the stage in just a moment, and we are incredibly grateful for his interest in Chicago and this project. He has become well known worldwide for his interview marathon project, and we're delighted to be hosting his first US marathon here in Chicago. What began as a conversation between the Terra Foundation staff and Hans Ulrich back in 2015 has led to today's great event.

We're very fortunate also to be partnering with The Richard H. Driehaus Foundation in both the presentation

Nora Daley.

of today's program and the presentation of Art Design Chicago. Thank you to Richard Driehaus and Kim Coventry for your partnership and your support.

None of this would be possible without our important partners here at Navy Pier and the fantastic team at EXPO CHICAGO. To Michelle Boone, Marilynn Gardner, and their staff at the Pier, thank you very much for allowing us to have this event in this historic and beautiful space. And thank you to Tony Karman and Stephanie Cristello and everyone at EXPO CHICAGO for including this program as a highlight of this year's fair and for your involvement in planning today's program.

And finally, we thank the Chicago Humanities Festival (CHF), with which the Terra Foundation has had the pleasure of working for the past fifteen years. Phillip Bahar, Alison Cuddy, and the rest of the talented team embraced the project and have put significant time and effort into realizing it, working with Hans Ulrich every step of the way. What we're about to experience is an incredibly thoughtful and dynamic portrait of creativity in Chicago. Its past, its present, and its future.

Congratulations to CHF and Hans Ulrich, and thank you all for your hard work.

Alison Cuddy
Marilynn Thoma
Artistic Director, Chicago
Humanities Festival

Good afternoon, everyone. Good afternoon, Chicago. Thank you so much for being here. I'm Alison Cuddy, the Marilynn Thoma Artistic Director at the Chicago Humanities Festival, and I'm just thrilled to welcome you to *Creative Chicago: An Interview Marathon with Hans Ulrich Obrist*.

Thank you, Nora, and thank you, Mark Kelly, for setting the stage for us, for your comments and your support. I too want to thank our partners at the Terra Foundation, especially Jenny Siegenthaler and Eva Silverman. At EXPO CHICAGO, I want to thank Tony Karman and Stephanie Cristello, and at Navy Pier, Michelle Boone and Dylan Hankey. And I owe a special debt of gratitude to Joseph Grigely and his assistant, Katy Snow Niner, for their support and wise counsel on this project.

I'd also like to thank Alison Schein Holmes and Matthew Byrd of the Studs Terkel Radio Archive. Studs is going to be a very powerful presence this afternoon, and I'm really excited for you to re-encounter him in this space.

Thank you to Elizabeth Amy Liebman for her generous support, and to *Surface* magazine and Make It Better for being our media sponsors. And I want to thank Herman Miller, especially Melissa Harmening, for the beautiful chairs on our stage. Before we go into this, I want everyone who is here today from the Chicago Humanities Festival, EXPO CHICAGO, and Navy Pier who is working on this, to please stand or raise your hand in the air. I just want to thank all of you so much. It's been hundreds of hours to get to this point, and I can't thank the team who's worked on this enough.

But now on to the man of the hour, or the five hours. It's been my immense pleasure to work with Hans Ulrich Obrist over the past year and a half. He's the kind of person who you could say needs no introduction. And certainly no introduction can fully capture everything he's done—his commitment, his cultural interests, above all his commitment to artists, the ways in which he collaborates with them, exhibits their work, and of course interviews them. Hans Ulrich Obrist is the artistic director of the Serpentine Galleries in London. And since 2005, he's curated The Interview Project, conducting long-form interviews with artists all over the world, sometimes in their studios and sometimes en masse, like we'll do here on stage today. He's a prolific writer, thinker, and author of numerous books, including *Ways of Curating, Do It: The Compendium,*

and multiple volumes of his collected interviews. And he drives many long-term projects, such as 89plus, which is an international, multiplatform effort dedicated to the innovations of the generation born after 1989. This is, as Nora said, his first-ever American marathon, and though his marathons always necessarily have to do with cities, what he will do over the next five hours with Chicago feels very unique and special. Today's laboratory, the setting for this experiment, is not just any city, but Chicago.

I am hoping that today might be part of an unrealized, utopic project Hans described in an interview he gave:

But to curate a whole city would be interesting—what would a city made and run by artists look like? Not necessarily a master-plan eco-city, like in Abu Dhabi or Brazil, but more of an archipelago of artist initiatives that could form a new city. It would be a city in which lots of artists would also live. That is my kind of utopia—to do a city either on Earth or another planet. That would be the ultimate form of curation. . . . It would be very exciting to have a city built by artists— something like that has never existed. . . . Yeah, an art city!

So please join me in giving a very warm welcome to our art city, to Hans Ulrich Obrist.

Hi, everyone, ladies and gentlemen, friends and fellow travelers. A very warm welcome to you all for this marathon. Thank you so much to Alison, and to everyone who has collaborated. It is, as Alison said, a big collaboration of many organizations, of many, many people, an infinite conversation over many months. Of course, *Creative Chicago* as a marathon is part of the Terra Foundation's Art Design Chicago, and it's part of the Humanities Festival. I'm deeply grateful of course to everybody at the Terra Foundation, with whom we started this adventure more than two years ago: Elizabeth Glassman, Jennifer Siegenthaler, Eva Silverman, Maureen Jasculca. I'm deeply grateful to EXPO CHICAGO because many of my trips to Chicago over the last couple of years have included conversations with Tony Karman, Stephanie Cristello, and their teams. And, of course, all my thanks go to the Humanities Festival, to Alison, Phillip Bahar, Shanna Brown, and also to Eddie Medrano, Emmett Mottl, Brittany Pyle. You should give a very big applause to this amazing team.

I also want to thank everyone at the Serpentine Galleries, especially Yana Peel, Claude Adjil, Lucia Pietroiusti, Laura Macfarlane, and Laura Norman, as well as my team, Lorraine Two Testro and Max Shackleton.

Also, the Driehaus Foundation has been very helpful. And we are grateful to them. And as Alison said, everything really started with Joseph Grigely. I'm deeply grateful to my friend Joseph, for twenty-five years of friendship but also our long-term collaboration on my archive, which is partially here in Chicago, archived by Joseph as an artistic project of his. A bit later, he's going to tell us about this more. So we can say everything started with Joseph, and we can also say that everything started with Studs Terkel. We're very grateful of course that we can show here archive sections from the Studs Terkel Radio Archive.

When I first came to Chicago, in the 1990s, I had just started to curate. I had done my "Kitchen Show," and I was invited to give a talk here at the Museum of Contemporary Art. I had never really done many lectures before, and I thought, I need to kind of learn something. Whenever I go to a city, I do these interviews with pioneers because I want to learn. So I went to see Studs Terkel, and I wanted to ask him everything I always wanted to know about how to conduct an interview, but also really how to use interviews to write

books, how to transform interviews into books, and also how to kind of keep an archive together. He had thousands of hours of interviews, and I had only about a hundred hours at the time. I was beginning my own archive. In a way, Studs Terkel's advice has been very precious, and I followed a lot of his advice. We would, actually, like to dedicate this marathon to his memory, to Studs Terkel. And you will see during the marathon there will be lots of clips and moments when we can remember Studs Terkel.

I want also to acknowledge the late Nancy Spero and Leon Golub, who were very close friends of mine, and that's of course another Chicago connection. They always said we need to connect to the Monster Roster. So I'm incredibly delighted that, for this marathon, we have an interview with Dominick Di Meo, who is now actually in New York City. He couldn't travel, so I interviewed him there. The interview is in *Newcity* magazine, and I think you can pick up a copy on your way in or out. His interview is about the Monster Roster movement, which we felt is very important as part of the memory here.

Now, the marathon will have a couple of recurrent questions, which we think is interesting. In our digital age we have more and more information but not necessarily more memory, and maybe actually amnesia is at the core of this digital age. We need to protest against forgetting. And for this reason, I think it's always interesting to ask about pioneers who have inspired our speakers today. So I will ask everyone today, who are their mentors, who is their Studs Terkel, who gave them courage and energy. Hopefully we'll rediscover through that a lot of forgotten practitioners and, in a way, contribute to the protest against forgetting. Often, we can, of course, invent the future with fragments from the past.

We also thought it would be interesting to look at different Chicago archives, because that of course ties into this connection I have to Chicago by way of archives. We are not only going to have the Studs Terkel Radio Archive. We're going to have a connection to the Sun Ra archive, thanks to Cauleen Smith. Many archives will be present in the conversations.

I'm also going to ask about unrealized projects. I'm interested in this idea of projects that haven't happened yet, and future projects, and of course very interested always

Studs Terkel, 1962. Chicago History Museum, ICHi-121582. Photograph by Raeburn Flerlage.

in what is missing. When Ernst Bloch was pushed against the wall by Adorno to finally define what he meant in his writings, he said, "Something is missing." So I'm interested in this idea of what is missing in Chicago, and we're going to ask the speakers about unrealized projects and what Chicago needs, what we could think of inventing.

And then, most importantly, we want to ask the speakers to ask each other questions. We already could see it earlier in the green room, where we met with different speakers. Many of them had actually never met. They've lived in this city for a long time but have never encountered each other. I believe that junction-making is key. It's important to bring people together. It's advice I received from J. G. Ballard, that we should make junctions. So I hope many new junctions happen today, between the speakers, between all of you. After the marathon, we will continue the conversation over drinks, and hopefully many more meetings can happen then.

Act I
Prologue

It's now the moment to introduce our very first speaker. Everything starts with Tim Samuelson, and we thought it would be amazing to have him here in this ballroom. He's the official cultural historian of Chicago, a role that finds him telling the stories of Chicago's past through exhibitions, books, public programs, and media features. Now give a very, very warm welcome to Tim Samuelson.

Tim Samuelson Thank you very much. Great to be here.

Thank you very much. So, Tim, it seems important to start today's interview by talking about where we actually are. We are in a ballroom on a pier, or actually in Lake Michigan, and I wanted to ask you to tell us a little bit about where we are.

Well, you are in what started out as a structure that was planned in Daniel Burnham's great Plan of Chicago from 1909. Its aim was to consolidate all of the lake shipping into one convenient location. But while you're doing that, you are building this giant structure out into the lake, and under Mayor Carter Harrison Jr., the idea was why not put a big public ballroom at the end where it could be a gathering place, where even in the warm summer weather you could come and get the cool breezes off of Lake Michigan. The Chicago Symphony could play amongst the waves of Lake Michigan.

It opened in 1916, this amazing place. The structure of it—you can see the rivets of steel. The engineer who

Tim Samuelson and
Hans Ulrich Obrist.

made this great span also did the metalwork for some of Chicago's first skyscrapers.

Mayor Harrison's plan for a great cultural place at the end of the pier in the lake was disrupted a little bit because he was no longer mayor at the time it opened. And who gets the job but William Hale "Big Bill" Thompson, the master of political bluster, hyperbole, someone of the people, somebody who would be noisy. Rather than many of the cultural events Harrison looked forward to, you had cheap beauty pageants, wild parties, and in some cases good things, like a place for jazz. Mayor Thompson here was also somebody who advocated the idea that America is going to be the center of the globe, and Chicago is going to be the capital of it all. He said that we should steer clear of foreign countries and entanglements, because it's America first. He would come up with unexpected things, like, to please the Irish voters of Chicago, he said that if he ever met him, he would "biff King George of England in the snoot." In other words, punch him in the nose.

Well, we were stuck with him for twelve years, till 1931, the last Republican mayor we've had. Thank God there aren't politicians like that running the government today...

So that's kind of your background on where we are right now.

It would be interesting to talk a little bit more about ballrooms in general, because as far as I know, Chicago has a big number of ballrooms, from grand structures like this to smaller neighborhood spaces. In a way, it's very much part of the vernacular architecture. Can you tell us a little bit about how they became such an important feature of Chicago's built environment?

Ballrooms and public gathering places can be found throughout the city in different scale and stages. These became gathering places, places you could have theatrical speeches, public events. A number of people who built the early ballrooms in Chicago very conveniently operated saloons on the ground floor, so that after the performance or the speech, you could go downstairs and discuss things further.

Also this was a great music town, a place that was an incubator of jazz. So you had ballrooms that were places for dance and entertainment and amazing performances, big ballrooms like the Aragon and the Trianon, but also small ones that you'll still find out in the neighborhoods. Like the Cinderella, where the light fixtures are shaped like the slippers of Cinderella and where jazz and other music once played. They've reinvented themselves over time in keeping with how the neighborhoods change and the people who live there.

And what could you say about the energy of ballrooms? I spoke the other day with the great poet Etel Adnan, and she was talking about this idea of energy. Ballrooms are obviously physical spaces, and they're also social centers where people can meet.

ARAGON, "THE WONDER BALLROOM," 1100 LAWRENCE AVENUE, UPTOWN CHICAGO

Postcard of the
Aragon Ballroom.

They're powerful places. Unlike a formal theater where you have people lined up and paying attention in one place, which is kind of what we're doing right now, they're gathering places where people stand around as a collective group and they react in unison. You can actually discuss and react, and the tenor of the ballrooms can change. Early on, some of the musical ballrooms were adapted with special lighting, and if you were playing a piece of music the color would change to go along with the music. But noisy political speeches, protests, those are also things that took place in the ballrooms. You

often think of a ballroom just as a place for dancing or fancy functions. They're real chameleons of public reaction.

Now I'm curious also because you have a very interesting job title. You are the cultural historian of Chicago. It's interesting because you're not working for a university or a museum as a curator, but you're actually working for a government. Can you tell us about this role and how it came about? It doesn't exist in every city.

My title is Cultural Historian of the City of Chicago. At one point when they first proposed my position, there was an idea to call it curator of Chicago, and I said I'm not taking responsibility for all of that. So it became cultural historian. I do put on exhibits and also organize programs.

You are looking at the entire staff of the cultural historian sitting right here. I wind up being the answer man for every kind of question you could ever imagine. I always say that picking up the phone is a combination of Russian roulette and lightning Jeopardy. You don't know what question is coming.

Well, I was also curious about the things and objects you preserve. Maybe we can look at one?

We can.

I'll admit it. I'm the history nerd, and I'm lucky—the history nerd wound up getting a job, and I have a lot of stuff. In fact, I have a storage place filled with things I won't even show my wife because if she saw it, that would be the end of it right there.

In addition to my job as the cultural historian, I've started my own not-for-profit archive full of things that people can actually touch. I always was put off by going to a historical museum and seeing things behind glass and people putting on white gloves to see them. I like the idea of being able to put historical objects in my pocket, and I can hand them to people and they can connect with them. I think that's really the way to do it. I'm not going to take some rare, fragile document and just toss it around, but common sense will say some things can hold up.

So today I've brought something that's part of the story of Chicago, from the era of "Big Bill" Thompson and

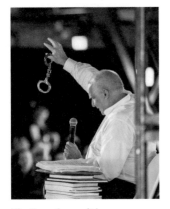

Tim Samuelson with
Eliot Ness's handcuffs.

the gangland era, when the thuggery of Al Capone and the gangsters was really setting the city on edge. During Prohibition, the US government decides to break the gang grip on Chicago, and the head of the Bureau of Prohibition wants to hire somebody to investigate and break up the illegal booze racket, because booze was illegal then. So what does he do? He gets his twenty-five-year-old brother-in-law to head it up. But this young man turns out to be Eliot Ness, the great crime fighter, the subject of the film *The Untouchables*. So, here in my pocket are Eliot Ness's handcuffs. In fact, if you want, you can even try them on. The lock still worked the last time I tried them. And I do have the key.

Also, I did some reading into you, and I saw your piles of books and your library and your archive—something I certainly can relate to. So, I'll also give you a souvenir to take with you. I am happy to present you with an original 1950, luridly covered paperback: *Chicago Confidential*, "the low down on the big town."

Thank you.

My pleasure.

It was written almost seventy years ago, but there's a lot of basic truths about a city that doesn't follow the rules. It has its issues and its dynamics, but it's a special place like no place else.

I did a long interview with Suellen Rocca and we spoke about lists, the amazing lists of things in her work. Lists also play a big role in your work, and there's a long list of things you've saved, preserved. The Chess Records offices on South Michigan Avenue, the St. Louis Union Station. I mean, many, many buildings: various sites around the Bronzeville neighborhood, Walt Disney's birthplace, the American School of Correspondence. We could be here for hours listing the things you've saved. I was interested to know who inspired you to help save all of these things? I read that Richard Nickel somehow gave you the courage and the inspiration at the beginning, and I wanted to ask you to tell us about what made Richard so important for you.

Well, one of my great teachers was Richard Nickel. I was just a teenager when I met Richard, and he was really one of the early advocates and fathers of modern urban preservation.

Here we are in a city that is famed for its architecture, a city that invented the skyscraper because land was precious. And you had people like Louis Sullivan, who built the first skyscrapers. And not only built a tall, metal-framed building, but was able to teach the skyscraper how to soar and honestly express its materials. But in the 1950s, not many people were paying attention, and when you tried to save a historic building, it was usually the home of somebody famous, like George Washington's house.

So in 1960, an early skyscraper by Sullivan, known as the Garrick Theater, was deteriorating. It was dirty and shabby, and people looked at it and said it was out of date and proposed tearing the building down. Nobody had the guts to stand up for an old skyscraper. But Richard Nickel makes a sign, goes to the building with a friend and starts to picket, saying not to tear the building down. Now, nobody would think of tearing it down, but that's because of Richard. He built an entire historic preservation movement.

Richard very nicely kind of adopted me, and taught me. We would go out to the neighborhoods on the South Side of Chicago where buildings were going to be demolished. We would advocate for their preservation. And we would lose. Richard would photograph the buildings. We'd get on our hands and knees and make measured drawings of them.

Richard Nickel at
the demolition of
the Garrick Theater,
Chicago, 1961.

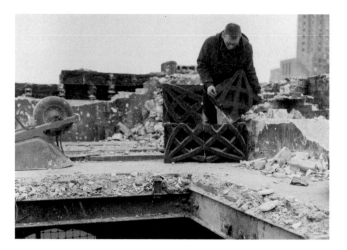

When it was over, we would save building parts from the rubble. It's kind of sad, but that's what you had to do.

With time, momentum started to build, and now there is advocacy for preservation. It goes beyond just the treasures of Chicago architecture. Things like the Chess Records building, a little modest two-story building on the South Side of Chicago, where the great blues recordings of Muddy Waters and Howlin' Wolf were made. That was actually threatened at one point, and we were able to landmark that. There is a power to these places. There is a vibe to these places. When you're able to visit them, you can pick up part of that vibe. In some ways, I believe these buildings are alive.

You've saved so many things, and in a way have realized so many things. I was wondering—we know a lot about architects' unrealized projects, but we don't really know about any other practitioners' unrealized projects. Do you have any unrealized projects, projects that have been too big to be realized, or dreams?

One of the things I am working on realizing now is probably the most formidable and scary task of my entire life: organizing my stuff while I still have the marbles and the mobility to do it. It's a lot of things, so if I get hit by the proverbial bus, people will look at them all and say, "What's that? What the heck does this guy have a pair of handcuffs for?" Part of what we're doing now is organizing things, photographing them, and also making it known they're available. I enjoy it when there's a small school or a program that wants to borrow an original piece of Louis Sullivan or Frank Lloyd Wright. You go to the big museums and they say, "Well, that's special. We can't let that out." But I can send it out there because it's my own stuff. There's a kind of almost anarchy in the way I run my archive, making historical materials as freely available as possible. So it's a work in progress. That's my dream, and we're working on it.

Thank you so much. Thank you very much. A big applause for Tim Samuelson.

Thank you.

Studs Terkel, c. 1960. Chicago
History Museum, ICHi-065439.
Photograph by Stephen Deutch.

Studs Terkel interviewed by Hans Ulrich Obrist (2006)

**Hans Ulrich Obrist I only started my inter-
view project ten years ago. It's very recent.
I started as a student, ten years ago. Now I have
four hundred hours.**

Studs Terkel Really, my god!

**But it is a very small fragment of what you've done.
So, I wanted to ask you for your advice. What would
be your advice as the world's greatest interviewer?
What advice would you give me?**

There is no advice. I think it's *listening*! The first thing
is to listen to what that person says. Sometimes—I think
we talked about this already—that person stops, pauses.
Why did that person stop? It might have been a certain
moment of hurt that person remembered. So you have to
go on. But remember where the person stopped, to come
back later on and pick up where they stopped. Maybe this
time he, she is well into the interview with you and is
more relaxed and you can bring it up again. And this time
that person might continue and explain why they stopped
earlier. So, LIS-TEN-ING.

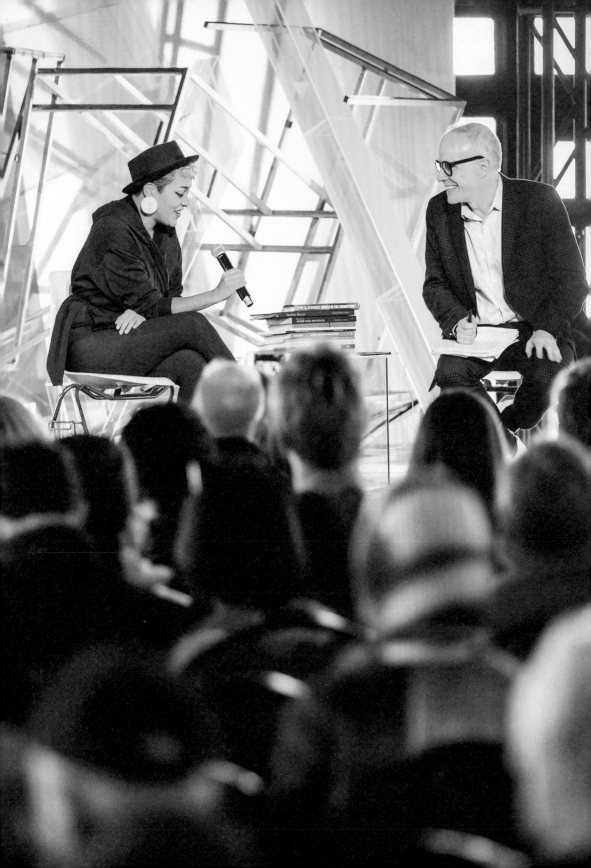

Listening. Studs Terkel says to listen. Etel Adnan, the great poet, tells me the twentieth century was the century of many manifestos and the twenty-first century should be about listening. When we started the marathons we always believed it's a format that can listen to a city, and that could not be a more wonderful transition to our next speaker. I am very happy to welcome our next guest, the amazing poet, writer, and sociologist **Eve L. Ewing**, who is also a professor at the University of Chicago.

She has written extraordinary books: *Electric Arches* and, most recently, *Ghosts in the Schoolyard: Racism and School Closings on Chicago's South Side*, a book you all need to very urgently read. A very, very, very warm welcome to Eve.

Eve L. Ewing The transcription live-captioned on the screen behind us said "writer and socialist," instead of sociologist! But I'll take it!

Welcome. Because we just were listening to Studs telling us to listen, I wanted to ask you: what does Studs Terkel mean to you? When did you first learn of him, and how did you begin to work with Studs's archive?

Eve L. Ewing and
Hans Ulrich Obrist.

Studs really stands out in our city's history as being one of our most important oral historians. He engaged in an act of what I would consider radical listening, because his ethos was that

everybody deserves to tell their story. If you go back through his archives, you hear him talking to Cesar Chavez and Martin Luther King and Mahalia Jackson and other incredible, legendary people. But you can also hear him walking up to people on the street or at a bar or on a train, and asking them about their lives. And what he taught us is that there's so much glory and beauty and mystery in the everyday lives of regular people. That's the Studs legacy that means so much to me.

I got involved with the podcast *Bughouse Square* when some folks from WFMT, which is where Studs had his radio show for a really, really long time, approached me and said, "We want to do a podcast as a way of activating the audio archive." The way each episode works is that we bring in some archival audio of Studs interviewing someone really phenomenal, like James Baldwin, who's on our first episode. There are a lot of podcasts, everyone has a podcast today. But not everybody has James Baldwin on their podcast, so I'm slightly flexin' about that. And then I interview a person from the contemporary moment who does analogous work or who brings new insights. It's been a really fun project.

Can you tell us a little bit more what's going to happen with the archive? Are you going to do more things with it? And how can we use an archive in a non-nostalgic way, to produce the future?

Well, we'll see what happens with the future of the podcast. We're doing five episodes to start. What I really hope is that people use it as an entry point to activate the archive for themselves. I'm a big believer in the importance of archives. I think that we all have our own personal archives, and I see them as a mode of time travel. When you enter into an archive, you're speaking to somebody that's not there with you. What they have left for you is an artifact to help you understand something about who they are and where they come from. And when it's an audio archive like this, it's so phenomenal.

We have a great website where educators, librarians, anyone can engage and listen to Studs's interviews. When I was a Chicago Public School teacher, I used to play Studs's old archival audio interviews for my sixth and seventh graders, and they would interview people in their lives and bring

them back. I think it's a powerful example of this kind of radical listening.

Last night I was reading your wonderful book *Ghosts in the Schoolyard*. You're a sociologist with a PhD from Harvard—or, as it says here, a socialist—and I was wondering how you see a connection between listening and the work you do as a sociologist, researching and writing about the dramatic situation of school closings in Chicago. How does listening to people, interviewing people, enter that research? And I'm also wondering how you connect to the way Studs dissected the issue of race in America. That's another connection, I think, to the archive.

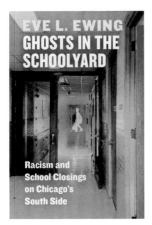

Eve L. Ewing, *Ghosts in the Schoolyard: Racism and School Closings on Chicago's South Side* (Chicago: University of Chicago Press, 2018).

Well, first of all, thank you for reading the book. I'm still in the new-book phase where I'm, like, "Oh! people are reading a book that I wrote!"

I think that listening is really at the core of it, because we live in a society and in a city where we are given messages all the time about whose life matters, about whose story matters, about who is important, about who is an expert on a topic. It's been a very contentious week in the United States [with senators debating Supreme Court nominee Brett Kavanaugh, and Bill Cosby being sentenced to prison for sexual assault], as people have a really hard time believing women's accounts of their own lives, for example. Listening becomes a way of undoing or eroding the paradigms that we have as a society about whose voice is speaking to fact, and who has the right to say what is true and what is not true. I try to use that as a tool in all of my work, in poetry and in media and communications and writing, and certainly in social science. I think that one of the most important things for researchers to do is just to understand that no matter how many books you've read or how many degrees you have, everyone is an expert on their own life. That's something I really believe firmly. And so my job is to just try to listen, and I have the privilege of being given some time and space to write it down. And again, that's trying to enact the legacy of what Studs gave us, which is this example of just paying close attention to people.

Can you tell us about some of your other inspirations from the past? I found a list of your favorite books, which inspired you. Audre Lorde pops up, Patricia Smith, Octavia Butler. Can you tell us a little bit about your inspirations, not only for your sociology but for your poetry?

One of my biggest inspirations, in terms of how I try to live my life, is Gwendolyn Brooks, whose centennial we celebrated last year. She was a person who, much like Studs, believed there's elegance and beauty and magic in the everyday, and there's something worth attending to in the neighborhoods all around us. Her book of poetry *A Street in Bronzeville* is all about that. She won a Pulitzer Prize for that book, and was actually the first black person to win a Pulitzer. She's a really big influence on my work, as well as Studs.

There are all of these parallel realities in your work. Can you tell us a little bit about what's next? Yesterday, I spoke with Theaster Gates about what's going to happen with the future of Chicago, who will be the next mayor. And he said it's not only about who will be the next mayor. It's a question of what we can all do. In relation to the school closure question, I was wondering, in a DIY way, what's your advice? What can we do to address that?

Eve L. Ewing, Kevin Libranda, Luciano Vecchio, and Matt Milla, *Riri Williams: Ironheart* (Issue 1, Marvel, 2018).

That's so many good questions!

OK, what's the future? I'm an Afrofuturist, so I don't think about linear time. I think that the future and the past are always happening. That's why I write about ghosts and time travel, and I find a legitimate way of bringing that into my professional life. I really believe in time travel—I think the future is constantly happening, every time we make everyday choices. Every day we have a chance to try to live the type of city we want to see in the future.

In terms of the future for me, I'm writing a lot of things that are kind of skirting the boundaries of reality. I have

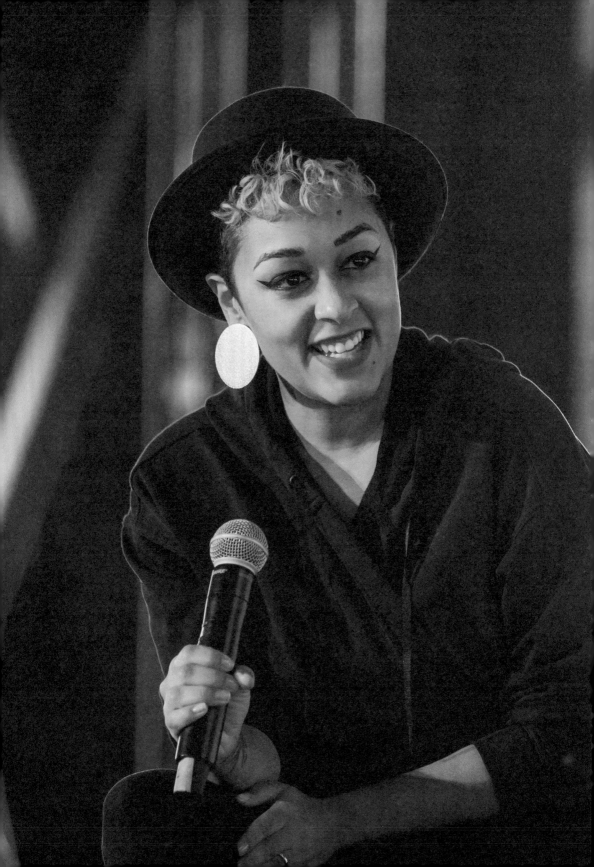

Ironheart, this Marvel comic debuting in November, about a girl from Chicago who's a superhero. Everybody should look for that. And I wrote a children's book called *Maya and the Robot*, about a girl whose best friend is a robot. That's coming out in 2020. So my own future is engaging a lot with the future, but I'm also always kind of obsessed with the past. I think they're just kind of the same thing.

When we did our Mexico marathon some years ago, Carlos Fuentes told me that he and many other poets, like Octavio Paz, had gone into politics. I'm thinking also about Tim, who spoke just before, who works within the city; about John Latham and Barbara Stevini of the Artist Placement Group; and about the conversation I had yesterday with Theaster, who said we need to bring art into society, we need to bring poetry into society. Is that something you're interested in?

Eve L. Ewing reading
from *Electric Arches*.

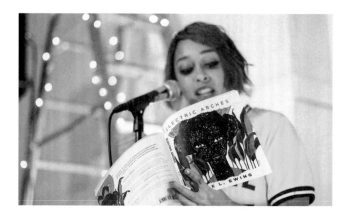

Absolutely. I don't even think there is any kind of viable alternative. Whether I want it to be or not, everything I do is kind of politicized. As a black woman, just walking around, being alive, continues to be a contentious point apparently. Everything I do in all of my poetry is very political, even if it doesn't seem to be on its surface, because I live in a country where it was illegal for my ancestors to read and write. So the very act of saying I'm going to make my living by putting something on paper is already politicized.

You've realized so many projects. You've written books, from poetry to sociology. You're incredibly present on social media like Instagram and Twitter. But there must be some unrealized projects. Again, architects always publish their unrealized projects. But we know very little about unrealized projects by poets or sociologists. What are your dreams?

I have twenty million unrealized projects...

What are the most urgent ones?

Every day I pray for a little more time to execute some of them. Something I've been thinking about a lot is what it would mean to open a bookstore. I've wanted to do that for many years, to think about bookstores as community spaces and spaces to hire people who have been incarcerated or young people. So that's a currently unrealized project. Check back with me in ten years, and we'll see if I pulled it off or not.

Can you give us another example? Because you have so many...

You're trying to get me to spill all my best work here!
There's a story that really fascinates me that I dug up from some archives recently. It's about a black woman who was attending the University of Chicago at the beginning of the twentieth century, and who was kicked out of her sorority when her sorority sisters found out she was black. Her tuition was being paid by her uncle, who was a notorious vice-den leader, gambler guy in Chicago, with the great name of Mushmouth Johnson. They have this whole amazing family story that's kind of a mob drama. Someday I'd like to write about that.

Eve, thank you so, so much. A big applause for Eve. Thank you very much.

Thank you.

Act II
Foundations

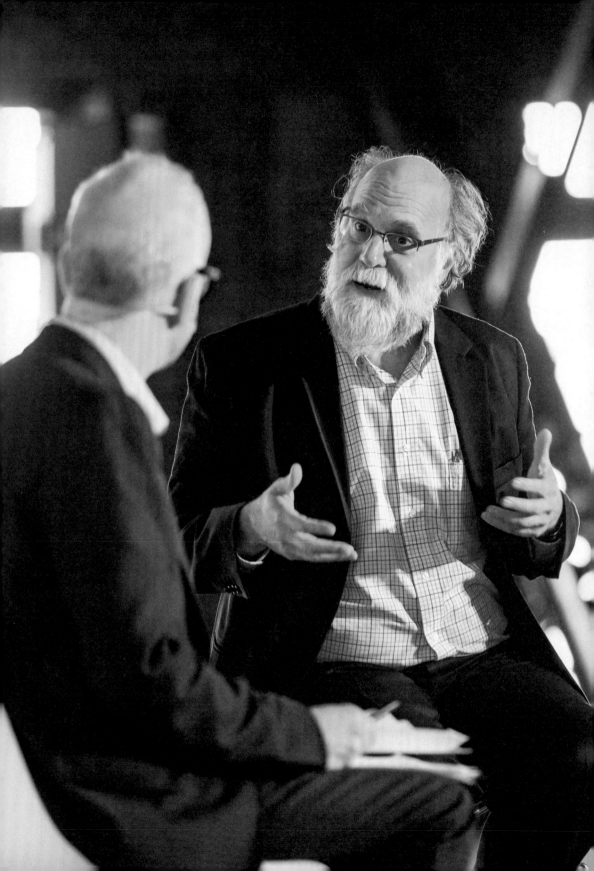

It's now my great pleasure to introduce our next speaker, Joseph Grigely. Joseph is an artist, a writer, and he's the head of many archives, including part of mine. A very, very warm welcome to Joseph Grigely.

We were listening to Eve tell us about the Studs Terkel archive, and archives play a very important role in your work. I wanted to ask you to tell us a little bit about how that all began and your story with archives.

Exhibition Prosthetics by Joseph Grigely
Conversation with Hans Ulrich Obrist and Zak Kyes

Joseph Grigely, *Exhibition Prosthetics* (London & Berlin: Bedford Press & Sternberg Press, 2010).

Hans Ulrich Obrist and Joseph Grigely.

Joseph Grigely Well the story with your archive goes back to 1995, I think, when we first met and you had already begun your publication projects. It struck me that they didn't quite fit into the normal scheme of what an art publication should be. They broke a lot of conventions, shall we say.

I said to you, "Please send your publications on a regular basis. I'll archive them, organize them." I remember the first two years, it was nice and easygoing. There would be one box with five publications, another box with ten publications. Then all of a sudden there were twenty. There were forty. There were sixty. There were a hundred and twenty. There were five hundred. There were fifteen hundred. There were twenty-two hundred. And we're still growing.

A big part of the project involves trying to understand how the art publication functions as a prosthesis, as an extension of an exhibition, and not simply a supplement. This was the basis for my book *Exhibition Prosthetics*, which also looks at the publication as an exhibition, and the way the publication works to take the exhibition somewhere the exhibition doesn't go.

And when we started this process, you already had other interesting archives. I remember particularly the archive of the late Gregory Battcock, which was actually the basis of an installation in the 2014 Whitney Biennial. That's another urgent book for all of you, if

you haven't read it, *Oceans of Love: The Uncontainable Gregory Battcock*. It's really an archive that you saved. We're talking here about a very important archive of art history that would have disappeared without you bringing it back *in extremis*. Can you tell us about the saga of the Battcock archive, why it is so important, what we can learn from it?

The Battcock archive is not very well known, much as Battcock himself isn't that well known. He started off as a painter in the 1960s, and then became a critic and art historian. He earned a PhD at New York University.

It so happened I had a studio in Jersey City, New Jersey, in a large building that had originally been occupied by a moving and storage company. In the early 1990s they were evicted from the building. The artists who had studios in the building entered the space after the movers left. There were papers and books in boxes all over the space. And I saw the name Gregory Battcock and thought, "Wait a minute. Wasn't he a critic?" So a friend and I gathered up everything we could, enough to fill about seven or eight boxes, and discovered a little later that Battcock had been murdered in 1980. And right away it registered, that's something unusual. I mean how many art critics are worth murdering? How many have been murdered? So I did a lot of work trying to understand how the archive presented a cross-section of the art world of the 1970s. And like any archive, it contains answers to questions that basically haven't been asked before. It's a depository for the future. The real question for archives is how to make the material useful for people in the future, how to make it accessible, how to map it. The Whitney installation and the book on Battcock both attempt to address these questions of access and mapping.

Last night I went to your place and saw your many other archives, like the archive of your conversations, your many, many thousands of conversations. That archive has a lot to do with the relation between written language and speech. Can you tell us a little bit about this extraordinary archive of your conversations?

Well, the archive of conversations is pretty unusual in the sense that it's an archive of ordinariness. Since I am deaf, and

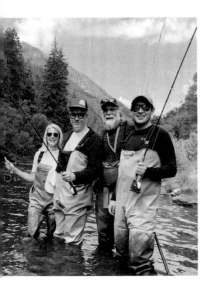

can't lip-read well, everyday conversation is challenging. I mean lip-reading is so inefficient—when you say "vacuum," it looks like you're saying "fuck you." It's so easy to get things entirely wrong. So asking people to write things down helped avoid awkward, unpleasant situations.

At first I didn't know the importance of those little notes people were writing. But after a dinner with a friend when there were papers on the table, under the table, in the kitchen, on the couch, I thought I'd save them, and put them aside. One day I spread them on my studio floor and looked at them carefully. They weren't really writing in the usual sense. It was instead talking—on paper. It was perfectly ordinary conversation, things we don't normally write down. For me that's why this archive is significant. I think it was Yona Friedman who once said about archives, They're just big waste paper baskets we never empty out.

Another archive within your collection is the amazing archive of fly fishing. We went fly fishing together this summer, and of course I didn't catch a fish because I don't know how to do it. But you're a world expert at fly fishing, and in your archive there are these amazing, amazing objects from fly fishing research and books. What's the connection between art and fly fishing?

That's a really good question. It's essentially about the flies themselves and their relationship to art. With fly-tying and art, basically you're using materials to make something else, and in the process you're making meaning. In the archive, both flies and fly-tying materials raise questions about process and methodology. We tend to think of art as being about the product and the exhibition. But what's often missing is a record of how things get made, how materials are transformed in the studio. This is where the archive becomes important: it contains the histories of making. Details otherwise unseen and unknown. It's about how fur and feathers and tinsel and thread combine on the space of a hook to create something that is otherwise. So for me, getting inside of fly-tying reflects what goes on in the process of making art.

I wanted to ask you also about unrealized projects. Of course, there must be projects that have been too big

to be realized or too small to be realized. The range of the unrealized is really wide—a project that has been forgotten, or lost public art commissions, or maybe other projects that were censored. Or, as my friend Doris Lessing always said, the projects one maybe doesn't dare to do, a kind of self-censorship. There are many, many reasons why a project can be unrealized, and I wanted to ask you to tell us about some of your unrealized projects, or maybe unrealized archives.

I'm thinking of one particular project that I did that was never realized as a public art project. To give a little bit of context, I'm often asked who my favorite artist is and I frequently respond, "Thurgood Marshall." And people look perplexed and say, "Thurgood Marshall! But he was a lawyer and Supreme Court justice. How can he be so important as an artist?" The answer is in how he did seemingly impossible things, like trying to get people in *Brown v. Board of Education* to see a fundamental human issue in a very different way. In a certain sense, that's what a lot of us try to do as artists—get people to see and imagine the world in a fundamentally different way.

His work inspired me to do a project that isn't well known at all. It's called *United States of America v. GPH Management*. This was related to the Gramercy International

Art Fair, held at the Gramercy Park Hotel, which had very inaccessible conditions for people with disabilities. The challenge was to get the Department of Justice to take on the case and sue the hotel, and for me it was a fifteen-year journey from beginning to end. It wasn't done specifically as an art project, but for me the unrealized aspect of it is to get it recognized as an art project. Activism can be many different things, and I am most interested when it asserts itself legislatively and legally, especially in relation to disability.

As a last question, we've been looking at images of the archive. If some of our visitors here today, if some of our participants in the marathon, want to visit the archive, how does one visit the archive at the School of the Art Institute?

We have a website—huobrist.org—which represents and shows the various activities we're doing in the archive. And there's contact information there. If anyone would like to visit your archive, they can go to the website, contact me, and set up an appointment and see twenty-five years of publications and publication projects. Right now we have an exhibition of your hotel drawings up. A lot of people don't know you make drawings, but this is one of the secrets that we found when digging deep, a box filled with hundreds of your drawings.

Hans Ulrich Obrist Archive, southwest corner.

You're going to see another clip now of Studs Terkel. And just as a matter of transition, I wanted to ask you, Joseph, to tell us what Studs means for you.

I was looking at the quotation you showed earlier—when you first asked Studs Terkel for advice and he said, "Listen. Listen to people. Listen to the silence." That was a beautiful comment. Maybe because there's a world in the silence. To be honest, I really don't know Studs's work. I've never heard him, I've been deaf for fifty-one years. But that quotation really registers for me—the importance of the pause, the silence.

Amazing, Joseph. Thank you so, so much. Big applause for Joseph Grigely.

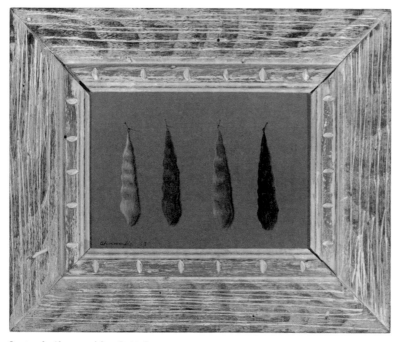

Gertrude Abercrombie, *Switches*, 1952.
Oil on Masonite, 3⁹⁄₁₆ × 5⅜ in. Collection
of Museum of Contemporary Art Chicago.
Gift of Albert and Muriel Newman, 1982.11.

Gertrude Abercrombie interviewed by Studs Terkel (1977)

Studs Terkel Now I'm thinking about your painting. How do you feel when some describe your work as surreal?

Gertrude Abercrombie Well, I think that's all right. Some people say fantasy or they just call it all kinds of things. It isn't that you said it right. It's just me. It's just what I'd ... well, a very good example is I was, I think, sleeping on the second floor one night. I slept in every room in this house including the furnace room, I think. And I woke up one morning and this thing was in my head. It was of four switches, black, brown, kind of blonde, and half blonde, I guess. I don't know. And right away I got up and painted it. And it's out there in the hall. It was a dream, a complete dream. And that's fun, to have dreams about something and then you paint them. You don't have to sit and worry about it. I never did sit and think about what to paint. Well, I have a million in me right now.

Hans Ulrich Obrist

And speaking of dreams, when we first started thinking about this mini-marathon, we thought it would be really a dream to bring together the Hairy Who and AfriCOBRA, because it's extraordinary that these two groups of artists developed in Chicago at more or less the same time, but the artists did not really meet. We have today a historic occasion: it's the first time ever that Gerald Williams meets Art Green and Suellen Rocca. Please give them a very, very warm welcome.

Gerald Williams is a painter and founding member of the artists' collective AfriCOBRA. Art Green and Suellen Rocca are original members of the Hairy Who.

I wanted to begin with a few individual questions. We'll keep that short because I thought it would be nice if you actually ask each other questions. I think you've prepared a couple of questions for each other.

I wanted to ask Gerald first to tell us about AfriCOBRA. I went to see the extraordinary AfriCOBRA exhibition at Kavi Gupta Gallery yesterday, and was wondering about the inspiration behind the name of this group, and also if there were texts or manifestos behind it.

Art Green, Gerald Williams, and Suellen Rocca.

Gerald Williams AfriCOBRA was an offspring of several artists who had worked on the Wall of Respect, a tribute to heroes familiar to the black community and to the world in general. They completed the Wall in 1967. Wadsworth

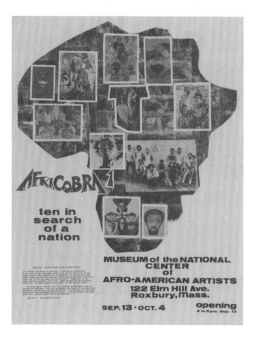

Poster for *AFRICOBRA I: Ten in Search of a Nation* at the Museum of the National Center of Afro-American Artists, 1970. Print, 11 × 14¾ in.

Jarrell, Barbara Jones-Hogu, and Jeff Donaldson were three of the artists who helped paint the Wall. They, and especially Jeff Donaldson, felt the need to continue the energy and the process of relating to the community. Jeff had gotten together some artists to form a group to discuss ways in which artists could be active in the community as artists. So he had me, Barbara, and Wadsworth and his wife, Jay, come to a meeting. We just talked in general about conditions in the city, world events, and a whole potpourri of issues going. We discussed these things at several meetings over the next couple of years.

The name AfriCOBRA is an acronym for African Commune of Bad Relevant Artists, bad in the sense of, "Hey, that's bad," as in cool. I think we all kind of relate to that vernacular.

Anyway, over months, we began tossing ideas into a reservoir, so to speak, of what can we do as artists that nobody else has done or what ideas can we express that need to be amplified and magnified. We developed some principles to break away from Eurocentric modalities and sensibilities. It included a concept of color because we felt color was something that we didn't have to limit, that we could use color unlimited.

At the time, as many of you may remember, color was all over the place with the modes of dress that a lot of people adapted to express themselves. It was common for somebody to wear a pair of purple pants and a green shirt—just an uninhibited use of color and fashion.

There are other elements as well. We decided that we would do a work based on the principles that we had decided to experiment with. The subject of the work was the black family, which was key to the strength and development of our community. Each artist brought in their perception of the black family. Mine was based on the James Brown song "Say It Loud, I'm Black and I'm Proud." The others did paintings that expressed their views. From that sprang some other works. We decided that maybe we needed a name. The word "cobra" had come up previously as a possibility, but that was an acronym for the Coalition of Black Revolutionary Artists. So, we decided on the name AfriCOBRA, and that has endured for fifty years.

And who were your inspirations? Because we're speaking a lot today about the future and inspirations from the past, who were artists of previous generations who inspired you? What were the inspirations for AfriCOBRA?

Gerald Williams, *Messages*, 1970. Acrylic on canvas, 48 × 38¾ in. The David and Alfred Smart Museum of Art, The University of Chicago. Purchase, The Paul and Miriam Kirkley Fund for Acquisitions.

I don't have any specific inspirations from the past. I can tell you, in maybe a roundabout way, I took a class in design from an artist some of you may know, Seymour Rosofsky, and indirectly he kind of influenced what I was about. I was at Chicago Junior College at that time, and I brought in some drawings, and some of them included some ballet dancers, and he looked at them and then looked at me and said, "Well, what do you know about ballet? Draw what you know, draw about stuff that you know." I wasn't offended by his comment. I understood what he was talking about. There was this rich community out on the South Side where I grew up, and it was a feeling that there's a vibration out there, there are thoughts and feelings and ideas that are out there in that community. And although I had at that time recently gone to see a ballet, something called *Coppélia* or something like that, you know, movement and color and the music were all kind of universal ideas, in the sense that everybody generally

appreciates music and ballet from other cultures. That was an indirect influence.

A member of this marathon later on will be Richard Hunt, a preeminent sculptor in Chicago and in the country and in the world. I read about him winning a prize at the Art Institute. I believe at that time he was fresh out of high school. He was a young man. And I read about him in the *Tribune*. Some people in my high school—Englewood High School, a school that no longer exists—talked about him, and I didn't necessarily want to pursue art as a career field. But it happened during my freshman year at Roosevelt University, just down Michigan Avenue.

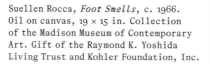

You mentioned energy, which brings us in a way also to the Hairy Who, because both groups or movements have a lot to do with an amazing energy between the members. Suellen, you said there was a lot of energy that passed between the members of the Hairy Who, and a lot of someone bringing their interest in a certain thing and opening it up to the others. Can you tell us about the beginnings of this Hairy Who energy? As far as I understand, there was a catalyst involved.

Suellen Rocca, *Foot Smells*, c. 1966. Oil on canvas, 19 × 15 in. Collection of the Madison Museum of Contemporary Art. Gift of the Raymond K. Yoshida Living Trust and Kohler Foundation, Inc.

Suellen Rocca Yes. So what you're asking is how the Hairy Who became the Hairy Who?

Well, at the Hyde Park Arts Center on the South Side, Don Baum was the director. Don, who I call the impresario—he is so important to the history of art in Chicago—had been having these shows called "Animal," "Vegetable," and "Mineral." They were large group shows, and I think most or all of us in what later became the Hairy Who showed in these exhibitions, although they were large group shows, so we only showed one piece. So Jim Falconer and Jim Nutt approached Don Baum with the idea of a smaller group show, which would

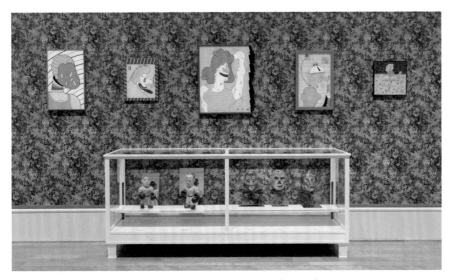

Hairy Who? 1966–1969, 2019. Installation view. Art Institute of
Chicago. Artworks by Jim Nutt, Suellen Rocca, and Karl Wirsum.

include Jim Nutt, Jim Falconer, myself, Art Green, and
Gladys Nilsson, the idea being, I think, that our work
would be very compatible. It would show very well
together, and we could show more work inasmuch as it
was only six artists—well, five at that time. Don liked the
idea, and he suggested adding Karl Wirsum to the group.
So we got together to plan the shows, and if you know
the individuals, it was a laugh session. We laughed and we
joked and we threw lots of ideas around, and then we got
off on a tangent and started talking about a radio program
on WFMT that was hosted by Harry Bouras, who was an
art critic and artist, and we weren't so keen on some of his
ideas, thinking that maybe sometimes he was a bit pomp-
ous. So we're talking about Harry Bouras and in walks
Karl Wirsum, and he says, "Harry Who? Who's this Harry?"
And that's how the name Hairy Who came to be.

I think what was unique about our exhibitions, three
of which occurred at the Hyde Park Art Center—in '66, '67,
and '68—was that they were really, truly collaborations.
We worked individually as artists in our own studios making
our work, but for each show we collaborated on creating
a comic book in lieu of a catalog. We also collaborated
on the posters for each of the shows. We installed the shows
ourselves, and the work, I would say, became more and

more like an early installation. For the third show, in '68, we covered the walls of this rather awkward, nondescript space—in the sense that it wasn't even originally a gallery space—with 1940s flowered linoleum. And if you go to see the Hairy Who show that's on right now at the Art Institute, they have found almost exactly the same kind of wallpaper that … not wallpaper—did I say wallpaper? I meant flowered linoleum … almost exactly the same kind of flowered linoleum that we used in the '68 show, which is really pretty incredible.

Anyway, so they were collaborations. We also did quirky things, like in one of the shows, we hung price tags from the corner of the paintings, big yellow price tags that said, like, $99.99. And we had cases full of our thrift store finds, old toys and things, objects that were important to us. And then we were invited to show at the San Francisco Art Institute, at the Corcoran Museum in DC, and at the School of Visual Arts in New York.

That's a wonderful answer that leads us straightaway to the question of inspiration that Gerald has already answered. I want to ask Art to tell us, in terms of the Hairy Who, who were the inspirations? Who were the teachers? Because of course both Suellen and you, Art, were in Vera Berdich's class together, and in a previous conversation we had here at EXPO CHICAGO when we did a panel three years ago, both of you told me about the importance of Ray Yoshida. Both Vera Berdich and Ray Yoshida need to be remembered, so I was curious if you can tell us a little bit about these influences and inspirations.

Art Green Yes. We didn't have all the same teachers, but Ray Yoshida was one important teacher for many of us. Another one was for me Vera Berdich, who taught printmaking, and Tom Kapsalis. They were all independent spirits in one way or another. Ray Yoshida was very interested in helping his students and encouraging them to find out what they were interested in, and it didn't have to be high art. He was interested in all kinds of pop culture things, comic books and so on. He and a group of friends would go to Maxwell Street. We went down there and found tremendous treasures, and a variety of interesting

things to see and listen to, blues players who were up early Sunday morning, passing the hat. Ray was very interesting. He was terrifying, actually, because he would tell you exactly what he thought in a way that was memorable. Years later, in the catalog for a show at the old Carson's building in honor of Ray Yoshida, they reprinted a critique sheet, and he had written on it, just to remind himself, his criteria for critiquing art. And one of the criteria was, "Is it brave or is it cowardly? Is it true or is it false?" He didn't want anyone to jump on anyone else's bandwagon, and he would point out when you were doing that. And he would tell you, "Well, you've been 'promising' long enough. You better get to work." He was a bracing influence.

Vera Berdich, in my experience, was very interesting as well, because she would teach, but she would often sit in the corner of the studio working on a plate. She had a source in the R. H. Donnelley Company, which printed *Time* and *Life* and all these magazines, and they gave her the proof plates they used to print proofs of the magazine before they made the rotary plates to print the final copy. And she would sell those proof plates to students or give them to students or work on them herself. There would be images on them, and she would scrape away parts and add other parts. Along with Ray, she introduced me and

Post-it Note,
Art Green.

others to using the world around us in our work. And not thinking about inspiration as coming from on high, but looking around at your feet and seeing where you were standing. She was extremely influential. I remember Suellen working on these enormous plates next to me. There were catalogs of jewelry and other items related to passages in one's life.

Thank you very much. I have many more questions, and we could talk about lots of other inspirations. Suellen told me a lot this afternoon about the Field Museum of the 1960s as an inspiration. When I recently interviewed Betye Saar in Los Angeles, she also told me about when she and David Hammonds visited the Field Museum and how that completely inspired their practice. But we don't have time for all of that. What we do have time for is the questions you have for each other. Who wants to start?

Post-it Note,
Suellen Rocca.

Suellen Rocca Well, I have a question for you, Gerald. I noticed on your biography that you've done a lot of teaching and that you've also taught in some unusual

capacity, as arts and crafts director for—is it the
marines or the army? Is that correct?

Gerald Williams Almost.

Suellen Rocca Almost, all right. I've done a lot of
teaching in a lot of different situations too. So I was
wondering how that influenced your work, or if it did.
Obviously, it was meaningful to you, because you did it
for quite a length of time. Could you talk about that?

Well, teaching was never the bulk of my career. It was
an important part. I was director of arts and crafts
for the air force, retired after twenty-two years. It may
be something that raises eyebrows when I tell people
that. They say, "Well, what is that?" It's part of the
human side of the military. As you know, the military
provides recreational facilities and resources for its
members: a golf course, a fitness center, a library, the
whole works. It's the same as exists in most commu-
nities. There was an arts and crafts program that was
begun in the 1930s, I think, to provide members an
opportunity to pursue their interests in arts and crafts.
There are many, many talented individuals who are
members of the armed forces who in their spare time
pursued some of the classes that we offered, partici-
pated in contests and a whole spectrum of events. Our
facilities included a woodworking shop, where they
could make furniture and various other wood projects,
and an automotive repair shop, where they could work
on their own cars. My job was to kind of tie all that
together, in several locations.
 I think over the years, at least since I retired, the
program has kind of diminished in importance, or in
the list of priorities.

I was interested because I've taught in some unusual
situations. I taught a very interesting program for
the Department of Children and Family Services,
for children in foster care, and I loved working with
that program. I taught a program at the Art Institute,
taking four- and five-year-olds up to the galleries to
look at works of art. Boy, that was a trip. That was so

much fun, because they really see things. I think for me, teaching in all these different kinds of situations has been inspiring. I love children's art. I'm very inspired by children's art, and I taught preschoolers and so forth.

Gerald Williams But did you have to beg the leaders for money?

Suellen Rocca No, no. It was more direct teaching. I didn't have to write a budget.

Yeah. That was the main facet of what I had to do.

I think, Suellen, you had a question for Art also?

Art Green, *Consider the Options, Examine the Facts, Apply the Logic (originally titled The Undeniable Logician)*, 1965. Oil on canvas, 89¼ × 68 in. The David and Alfred Smart Museum of Art, The University of Chicago. Purchase, Anonymous Gift.

I know Art so well. I mean, I admire Art so much and I love knowing him and showing work together with him. I guess I'd like to know, do you have a project that you have in mind to do in the future?

Art Green The future keeps getting closer and closer and shorter and shorter.

My main project that is probably too ambitious for me to complete in this lifetime is to clean up our basement.

Believe me, when I finish a painting, I often think, "Well, that's it. I've done it all. No one should top that."

And then after a while, doubts start creeping in, and I start getting irritated with myself and I start to do another painting, but I don't have a painting in mind. I hope I have a painting in my future. I hope to complete some more of those.

But you know, it is a matter of organizing your life, and so cleaning up my basement is probably a metaphor for cleaning up all the mess I've made over my life and leaving it in a state where whatever poor soul has to assess it after I'm gone will have some guidance in the matter, and not just throw up their hands and say, "Well, take it all away!"

> **Suellen Rocca** I have to say, Hans, that I've been inspired by thinking about archives. I think I shared with you that I've saved everything, every clipping, every catalog, but it's not in any kind of order that makes sense, and perhaps working with somebody else, collaborating, learning more about how to put it together … I think it's very interesting, and your approach to archives is so totally creative that it's very inspiring.

Thank you so much. Do we have questions from Gerald or Art for each other?

> **Gerald Williams** Yeah. Did all of you know each other before you became Hairy Who?

Art Green We did, as Suellen said. There were not very many public galleries here at the time, and there were not any that were particularly interested in our work. There were a lot of young graduates from the Art Institute, and there were big group shows. There was an artist organization that was set up called Participating Artists of Chicago (PAC), and during the few years of its existence, PAC arranged shows for members at rented venues, as well as at Hermann Hall on the IIT campus. I met other future members of the Hairy Who through those shows, and through Don Baum at the Hyde Park Art Center. I think I had met everyone in the group, that we mostly knew each other. I knew Karl from seeing him on the way to

school. Karl was a mystery man, a very rational person and interesting, a little older than me. One day he was in the cafeteria wearing, as he always did, a hammer hanging from one side of his pants and a flashlight hanging from the other. People wondered, but were too scared to ask, why he had them. So I screwed up my courage, egged on by my friends, and I said, "Karl, what's with the tools?"

And he said, "Well, I live in a loft, and there's a very tall stairway with one light bulb about twenty feet ahead, and there's no window in the door, so I have my flashlight in case the light goes out."

Aha! And so I said, "Well, why do you have a hammer?"

"Well, I have a padlock on the door, and I'm afraid I'll forget the combination. So I have my hammer."

And so I knew and admired Karl. I saw a show of his at the Sedgwick Street Gallery up by North Avenue. The gallery was on the second or third floor, and the El tracks were right there so the train would come screeching up around the corner, and it looked like it was coming right at you, before it suddenly turned away and would be gone. When I looked at Karl's picture, it had the same effect.

So, yes, we pretty well knew each other.

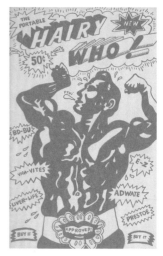

James Falconer, Art Green, Gladys Nilsson, Jim Nutt, Suellen Rocca, and Karl Wirsum, *The Portable Hairy Who!* (front cover), 1966. Four-color offset lithograph commercially printed on coated off-white wove, 11 × 7 in. The David and Alfred Smart Museum of Art, The University of Chicago. Gift of Dennis Adrian in honor of Don Baum.

Gerald Williams Was there a dominant big dog in the group?

Art Green I was a small dog.

Somebody who kind of held sway—

Well, I think people would have different views. It was a group effort. Jim Nutt and Jim Falconer had both worked in art galleries, and I think they had more experience in the art world than the rest of us. Along with Gladys Nilsson, they're the ones who went to Don Baum and suggested the show. We always had our meetings in Jim [Nutt]'s and Gladys's apartment, which had stars painted on the ceiling. It was in the basement.

Art Green And clouds, yes. I listened to them with great respect. And also Karl. I think we all admired Karl. As I said, he was a bit of a mystery, and we didn't know him all that well. I think we were all affected by each other's presence, but Karl with his penchant for punnery, of the best or worst kind depending on your point of view, affected us all. Our meetings were structured around a rigorous principle of free association, so whatever came up, we would develop that, and then what that rhymed with, we'd probably go there. It's a wonder we got anything done!

Suellen, Gerald, Art, thank you so, so much. Let's hope this is the beginning of many dialogues between AfriCOBRA and the Hairy Who. Another big round of applause for Gerald Williams, Art Green, and Suellen Rocca. Thank you very much.

Post-it Note,
Gerald Williams.

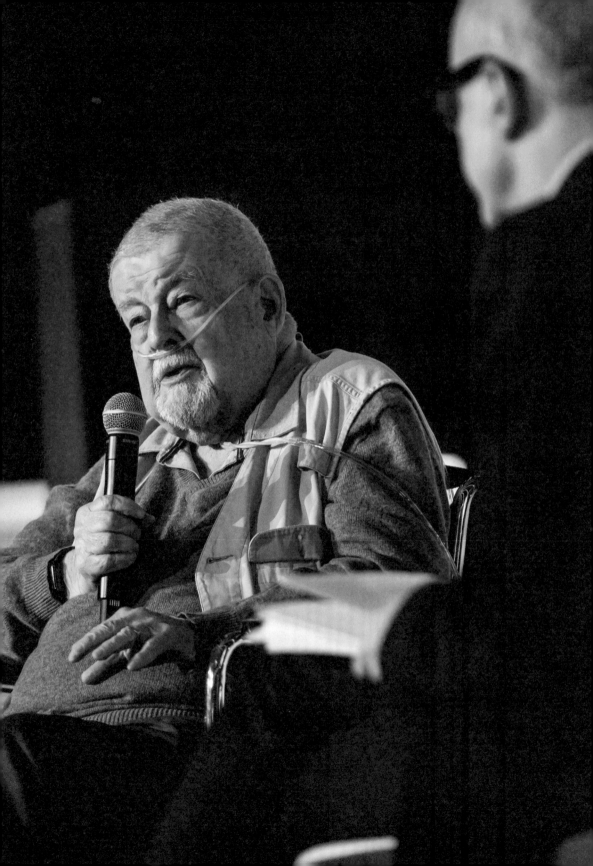

Hans Ulrich Obrist

It's now my immense pleasure to introduce our next speaker, whom I interviewed many years ago when I came to Chicago for the first time to interview Studs Terkel, the legendary Stanley Tigerman. Thank you so much, Stanley, for being here. Stanley, of course, needs no introduction.

Until 2017 he was principal in the Chicago architecture and design firm Tigerman McCurry, and he is a fellow of the American Institute of Architects. He has designed more than 450 buildings over the course of his fifty-one years of practice and has published an extraordinary autobiography, *Designing Bridges to Burn: Architectural Memoirs*, which is another urgent book for the growing list of books to read.

Stanley, you were a member of the Chicago Seven, part of the first generation of postmodern architects, whose guiding mission was to oppose the rules of modernist architecture. It's interesting, in mapping cities, to also map movements and groups. I've always been interested in this idea—through the interview project to make a mapping of groups. With Rem Koolhaas, I went to Japan and interviewed all the architects of the Metabolist movement, who remain so inspiring now. And I wanted to ask you about the Chicago Seven, about your movement and if there was a manifesto.

Stanley Tigerman, *Designing Bridges to Burn: Architectural Memoirs* (San Francisco: ORO Editions, 2011).

Stanley Tigerman and Hans Ulrich Obrist.

Stanley Tigerman I'm a Chicago native, and other than military service and college and graduate school, I've lived my entire life here. Together with my wife, who is also a native, I started a practice. Actually, I started before Margaret. Margaret joined me in 1982. But we couldn't imagine practicing anywhere else. Young architects, one of the questions they ask old geezers like me is, "Where

do we do a practice of our own?" My answer is always the same: "You go home. Wherever your home is." And they say, "Well, it's easy for you because you're from the most modern city on earth, because it burned down in 1871, it was rebuilt, became the Chicago School, blah, blah, blah." That's not true. One of my classmates in architecture school was from Mississippi, and went back to Yazoo City, Mississippi, and became *the* architect of the Delta. In other words, by going home, he had the longest, most powerful tenure, in a certain way. If you're loyal to your place of origin, it becomes very supportive of you. That's all I can say. So I came back here and started my own practice. And it's been a very long and fruitful trajectory.

Now, we're in the context here, not really of a symposium, because the marathon is a very hybrid format, but of some form of conference. And it's so fascinating because when we met for the first time, you told me that conferences play an important role for your work, and that in 1977 the Graham Foundation hosted your symposium "The State of the Art of Architecture." And when I, as a student coming from the art world, started to research architecture—which was long before I started to curate architecture—this conference kept popping up. It's a very legendary conference. Can you tell us about "The State of the Art of Architecture" and the role, for you as an architect, of curating and organizing symposia?

Well, I've had a kind of checkered career. But among other things, I both practiced and taught, doing both for more or less fifty-plus years. I always felt that teaching, curating, doing installations, doing art, painting, building, designing, drawing, were this whole panoply of possibilities, and they all fed into each other. Including words. You write. What is the impact of what you write and what you think upon your work? In turn, what is the impact of your work on the words that you use? Or what you teach? Or, perhaps more cogently, one is within one's own shell, and one needs to expand that.

One of my great experiences that elucidates that was my time at the American Academy in Rome in 1980. When

Stanley Tigerman,
The Titanic, 1978.
Photomontage on paper.

my wife and I went there, I was the architect in residence.
Now, normally, one spends one's time with one's own kind,
which is to say, architects hang out with other architects.
You're on juries, you give lectures, you do collaborative
projects. But at the American Academy, you never know
who you might sit down next to—Julia Child, which did
happen to me, or Kingman Brewster, the former president
of Yale University. So you have to make conversation with
others of great depth within their own fields. And that's
a challenge. But it's also, ultimately, when you process it,
rewarding to your own being, in the way that you work and
write and draw.

Another thing I've always felt is that the responsi-
bility of passing the baton to the next generation looms
very large. In part, I think, because it wasn't done for me.
The generation before me in Chicago did not support
my generation. And I felt I needed to change that. You
know, Chicago has this incredible architectural tradition.
Architecture is the sport in Chicago. It's not the Cubs,
the Sox, or the Bulls or the Bears, or whatever animal. It's
actually architecture. It's the only city where you can ask
a cab driver where Helmut Jahn lives, and he'll know. That
doesn't happen in other places. And so I'm very fortunate.
To be born in this city and become an architect in Chicago
is like being a Muslim in Mecca. I mean, it's home. It's not

Stanley Tigerman,
Anti-Cruelty Society,
Chicago, 1981. Tigerman
McCurry Archive,
Ryerson and Burnham
Archives, The Art
Institute of Chicago.

just the actual home, the literal home in my life, but it's
the home of my being, and what I've done with my life.
I mean, it is an architectural city. To be surrounded by
Mies, Frank Lloyd Wright, and all the progenitors that
came before me is a continual challenge. We live in a
Mies building, because I so respected him. I wanted to
be constantly confronted by what I consider to be excel-
lence, as a challenge.

Without making too much of it, we now, in the
autumn or near winter of my life, conduct a kind of salon.
Three years ago, after the first Chicago Architecture
Biennial, I told the young architects, the hotshot archi-
tects that were in the biennial, that we needed to contin-
ue that energy. So we invite a half dozen to a dozen of
them to our apartment once a month for a kind of salon
where we bring people that can be useful to them, poten-
tial clients or whatever. It's been encouraging to see that
truly terrific young talent be nurtured, to help them
come into being, as it were. I know I'm wandering, Hans,
but as you age, you begin to have whatever take it is that
you have on life, and architecture, you need to explain
that. So that people know where you're coming from.

**Thank you. I was wondering, given that you've
realized so many hundreds of buildings, if you**

could tell us about an unrealized project, one you regret not being realized, which you would like to see realized. What would it take to make it happen? Could it be done?

Stanley Tigerman,
Instant City model, 1966.

It's a project that I did in 1966 called *Instant City*. And it's housing. I would have loved to build that. But you know, what happens, happens. It didn't happen, so I don't dwell on it. It would have been interesting to see it come to fruition. I've been generally, though not entirely, proud of what I've done over this time. But I'm not one to clip coupons on accomplishments. And I tend to not look back. So what else do you want to know, Hans?

I've got so many more questions. Rainer Maria Rilke wrote this lovely little book of advice to a young poet, and given your incredible experience and wisdom from so many years of practicing, and seeing so many young architects here with us today attending the marathon, I was wondering what, in 2018, would be Stanley Tigerman's advice to a young architect.

Well, you either have, at your core, a sense of bravery or courage or you don't. I mean, it comes through your genetic makeup, and not so much your environment. Later in the marathon you'll have an architect here, Jeanne Gang, who's an incredibly brave, younger architect, in my view. Let me give you an example of that. I curated an exhibition for a former client of mine, the National Bricklayer's Union, at the Pension Building in Washington, DC. My job was to pick six architects from the United States. And of the six, I picked Jeanne as one. The others were from other parts of the States. And they were to work with masonry materials, which is a compressive material. And what Jeanne picked

Tigerman McCurry
Architects, Illinois
Holocaust Museum
and Education Center,
Skokie, IL, 2009.

was marble. The marble she used was pieces about nine inches tall, which were somehow attached to each other to form a gigantic showerlike curtain in the Pension Building. It was eighteen feet tall, a staggeringly beautiful object. Jeanne was trying to test the limits of the material's tensile capability. How far could it go before it deflected? Not fail, but be deflected. And when she put it up, it deflected visibly. It didn't fall down, but it deflected. I thought that was an incredible act of courage, because she found the limit of what marble could do before it broke. That, to me, is staggering. And you see it in, not all, but in many of her projects. Vista, the building she's putting up on the south bank of the east branch of the Chicago River, is an incredible building. It's three adjacent towers, of unequal height, that are connected to each other. One tower is concave, and the next one, attached to it, is convex. They act with each other to work against lateral loading, wind load. Because in a tall building the wind load is much greater on a cantilever than is compression. That is not just brilliant, but incredibly courageous.

My advice to a young architect is either you have it or you don't. You have that kind of courage, or you don't. You go with the crowd, or you try and work out something that expands upon, in our case, a very powerful tradition, as modernism grew in Chicago. So that's the first thing.

The second thing is, young architects always ask guys like me, among other things, when should we open our own practice. And I like to tell a story about a former student of mine. As many of you know, students and their teachers develop an affinity for each other. They get to know each other pretty well and can anticipate each other in a certain way. So this young man, who was employed, I think, at Skidmore at the time, called me up one day—his name was Ted Morningstar, by the way—and he asked to see me, and I knew exactly what he wanted to talk about, without him saying a word. He came to my office, and sure enough, all he did was sit down and say, "What are the odds?" In other words, what are the chances, if I open my own practice, of becoming well known, et cetera. And I said, "Well, if you're really courageous, and you work your butt off, and you're willing to sell your mother for a nickel, and you're in the right place at the right time, and you're really lucky, maybe 15 percent." And he said, "Thank you very much." And he got up and walked out, and opened his own practice, because he was brave. So I'm with that guy, who still has a practice today. I mean, that's the kind of person I admire, personally. I'm not interested in branding or marketing or all that bullshit, which is distinct from the profession of architecture and diminishes the discipline of architecture. It's the discipline of architecture that leads to Jeanne Gang, or to John Ronan producing this new building at IIT, which is permeable. It changes shape based on the wind, the rain, the sun, et cetera. I mean, these are very powerful moves, and tend to be staggeringly brave, and demand one's support. And Jeanne, she knows very well, if she does a bad building, she'll hear about it from me, straightaway. But if she does a great building, she'll also hear about it from me. And so, I'm interested in supporting the next generation. It's what my—without sounding too self-involved in this—what my legacy will be, actually. It's passing the baton, because one should do that.

There could not be a more wonderful conclusion, supporting the next generation. Stanley Tigerman, thank you so, so much. Big applause for Stanley.

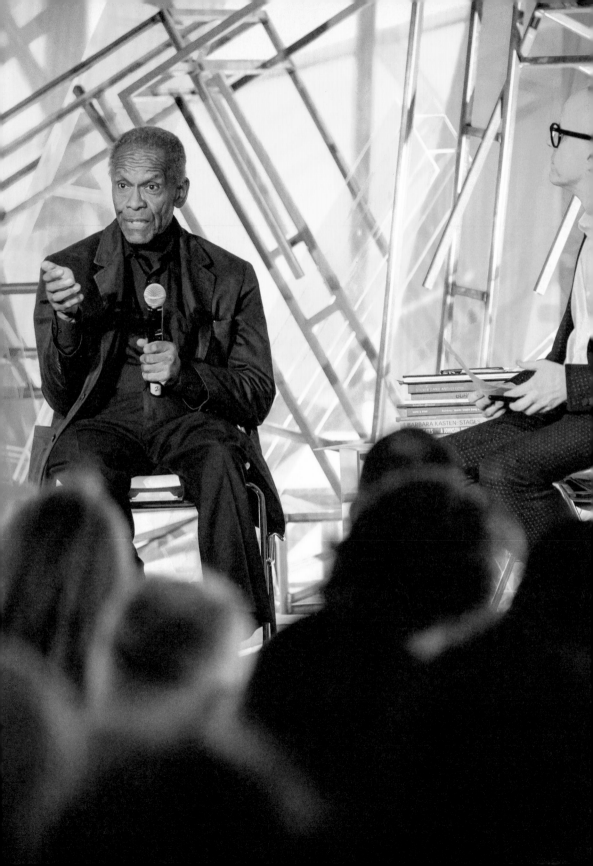

It's now my immense pleasure to introduce our next guest. Please give a very, very warm welcome to Richard Hunt. We've talked about unrealized projects, and it's been a magical moment for me, because my big unrealized project was to interview you, Richard, and do a studio visit.

So we spent hours yesterday looking at hundreds of realized public sculptures and other amazing work. I wanted to ask you how it all began. Who were your inspirations? How did you come to art? You showed me yesterday a book about your teachers, and I was curious about that.

Nelli Bar in her studio, 1942.

Richard Hunt and
Hans Ulrich Obrist.

Richard Hunt As some of you may know, as part of Art Design Chicago, the Museum at Oakton Community College decided they wanted to put together a show that featured my work and the work of two very important teachers, sculpture teachers. I had other art teachers, but in the end I decided to become a sculptor. And there were these two teachers. One was Nelli Bar, who I came to know as a student on Saturdays and in the summers at what was then, in the 1940s, called the Junior School of the Art Institute. There are some classes around the Art Institute for young people now, but not based on the same kind of model. Because it was like a School of the Art Institute for little kids that was modeled somewhat on the college, which then I went on to go to. So I had first this woman, Nelli Bar, my teacher in the junior school, and then Egon Weiner, as a teacher in the college. Before taking Nelli's sculpture class, I'd taken drawing and painting classes. And another thing is, in terms of nurturing my interest, there was a lot more art in the Chicago Public Schools in those days than there is now. In grammar school and high school. In high school, in a typical four-year program, you would take a year of music and a

Richard Hunt in
Chicago, 1962.

year of art. Then if you were interested in art, there was an art
major, so you could take *two* years of art. So I did all of that, the
music and the art.

Anyway, that was this kind of background. And after
I'd been a student for a while in Nelli Bar's class, she asked me
if I'd like to be a monitor; that's a person who would help mix
the clay and support the activities of the class. It was also an
opportunity for us to get to know one another even more than
as teacher-student, to spend time before or after class, have
lunch between the morning and the afternoon classes, talking
about art, maybe going up to the museum. Another thing that
was important, too, as I'm talking about it, is that it was an art
school in an art museum with a lot of treasures in it. During
this time, I would spend at least Saturdays in the Art Institute,
in the class and maybe stopping to look at an exhibition or
favorite pieces along the way.

So anyway, there was a lot to start off with and to
build on by the time I went to the college. And there it was
similar. A teacher would say, "Well, if you're going to the
lithography-etching class, why don't you go to the Prints and
Drawings Department and look at those Rembrandt etchings?"
The School was much more part of the museum than it is
now. The School of the Art Institute is an important school,
and has advanced into what you might call the twenty-
first century, with various ideas about art and vocation bring-
ing about a lot more interest in design and other things
beyond just painting and sculpture.

And there was also an interest in biology. You mentioned yesterday an interest in animals and in plants, and that, of course, led to this very interesting combination you found so early in your work, combining organic and industrial objects, right?

Well, yes. I've developed a style that I've worked in now for fifty-some years, that is, of direct metal fabrication, modeling, and using additive rather than subtractive methods. But anyway, there's looking at the figure, and another thing we used to do every now and then would be to go to the Field Museum and draw animals and other kinds of things in the museum. Then, in terms of my own interest in bringing together the possibilities of the medium I was working in, as a developed sculptor in direct metal, I had an interest in using that technique to be able to represent a broad range of things. Not only to represent things that were architectonic or planar or linear, but to give a sense of growth, a kind of natural form that had an industrial base technique.

But another thing that was important in my development is that I was very interested in history and biology, and if I hadn't been an artist, I'd have gone into one of those areas. Another job I had was working first in a genetics lab and then a zoology lab at the University of Chicago. I was involved with everything from taking care of animals, to creating slides out of tissue, and stuff like that.

You made a decision at some point many, many years ago to go into public art, and I think it's again a very important moment to focus on public art.
 A couple of months ago I was coming back from a trip really early one morning and I went straight to my office at the Serpentine. The cab driver assumed that I must work there because it was outside of opening hours, and said he wanted to tell me this story of visiting the park with his daughter during the summer. All of a sudden his daughter had run into the Serpentine Pavilion, our architecture commission, where there are no doors and you can just go into it. He said she had a transformative experience and now wants to become an architect. So he wanted to thank us, was obviously very happy, but at the same time not happy, because he said he never visits the

museum. It was just an accident that she ran into this pavilion. I asked him why wouldn't he go to a museum, and he said because he doesn't think it's for people like him. I thought that was extremely fascinating. There exist these many barriers. Of course, with public art you don't have these barriers. You go to the people and you can create an encounter for many, many people who would never go to a museum, a kind of transformative experience.

No other artist has more public artworks in the United States than you. You've done more than 150 public sculptures. I wanted to ask you to tell us a little bit about why, for you, public art is important.

Well, there's art to the people, for the people. Another thing about the development of public art in the last half of the twentieth century and now, is that from time immemorial there was public art in squares—you can call façades of cathedrals public art. You walk by in the square and there are all of these angels and devils running around. But then, in the period between the First World War and Second World War, there was a lot less art involved either in buildings or in public places. And then with the rebuilding of cities and

Post-it Note, Richard Hunt.

Richard Hunt, *Flight Forms*, 2001. Midway International Airport, Chicago.

other places, but particularly cities, in the "modern style," the International Style post–World War II, there were plazas that might have a little fountain in them or something but were basically just open spaces, unadorned. But then a few people said, "Why don't we put a sculpture out there?" And of course, in Chicago, where I was at the time, Bill Hartmann, the managing partner of Skidmore, Owings & Merrill, talked to Mayor Daley about putting a sculpture in the middle of what was then called Civic Plaza, now Daley Plaza. It started a round of sculptures, and in the case of what was then First National Bank, the Chagall mosaic, and the Calder where the Mies van der Rohe post office is. And in other cities, the same kind of thing was happening. Then the federal government started to develop a program through the General Service Administration, so that was investment in art programming on a federal level. Those things have helped to bring art into new kinds of public spaces, and have come to make it much more a part of the way the built environment is looked at by planners and developers. And it's there for people to associate with, both in terms of ideas and in terms of opportunities to see things, to see art without going inside.

I know we're out of time, but I have a very urgent last question. It's the question we've discussed with many previous speakers about what is missing, what is urgent, what does Chicago need. What do you think?

What Chicago needs very badly right now is the Obama Presidential Library. A little plug, but you know, it needs something that aims to bring people together. I mean, Chicago needs to deal with the separateness of various aspects of the community. If you go out from here, you see cranes, new buildings going up, luxury high-rises, big office buildings. Then you get a little further out, and there's a lot of land where there's the infrastructure, sewer lines and all, and all the buildings are gone. Big trees are growing up in lots that used to have houses with people who had jobs, and all that sort of thing. There needs to be more development in outlying areas, beyond downtown and the Gold Coast.

Richard, thank you so, so much. A big applause for Richard! Thank you very much.

Cauleen Smith, *Terrain* (2018)

Hans Ulrich Obrist We now have the world premiere of a film by Cauleen Smith. Cauleen is an artist whose primary discipline is film, and we worked with Cauleen on a project at the Serpentine Galleries in London this past summer. Kamasi Washington performed as part of our Park Nights series, curated by Claude Adjil. Cauleen is now editing a film she made of his concert, which took place in our Frida Escobedo Pavilion, where Kamasi played the architecture of Frida almost like a musical instrument. (And talking about the next generation of architects, Escobedo was the youngest architect to ever design a Serpentine Pavilion.) When we were in London, Cauleen told us about the research she had done here in Chicago and about the connection to the archive of Sun Ra. So we're incredibly delighted that she will join us later for an interview. But now, we will look at this film, *Terrain*, shot by Ian Curry, which has never been shown before. Thank you so much to Cauleen for premiering this film, *Terrain*.

Cauleen Smith, *Terrain*
(stills), 2018.

Cauleen Smith

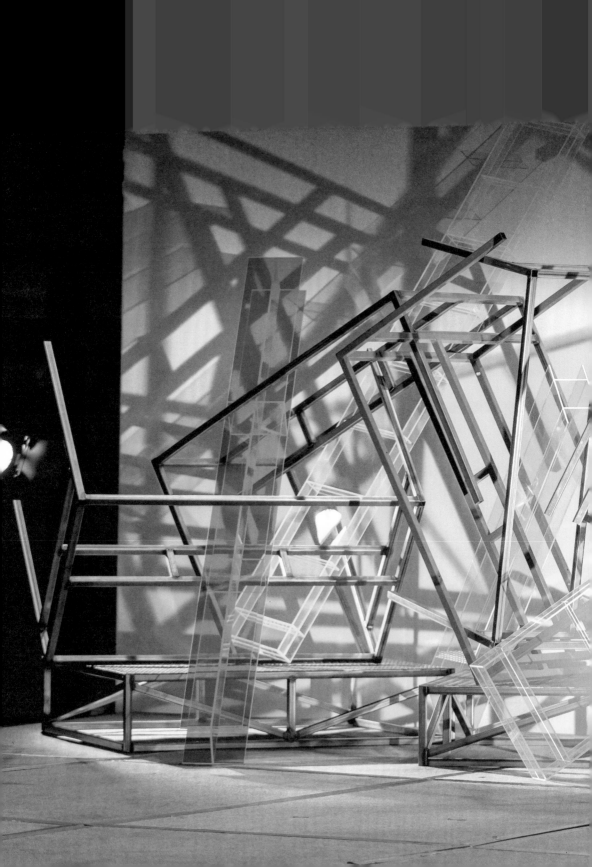

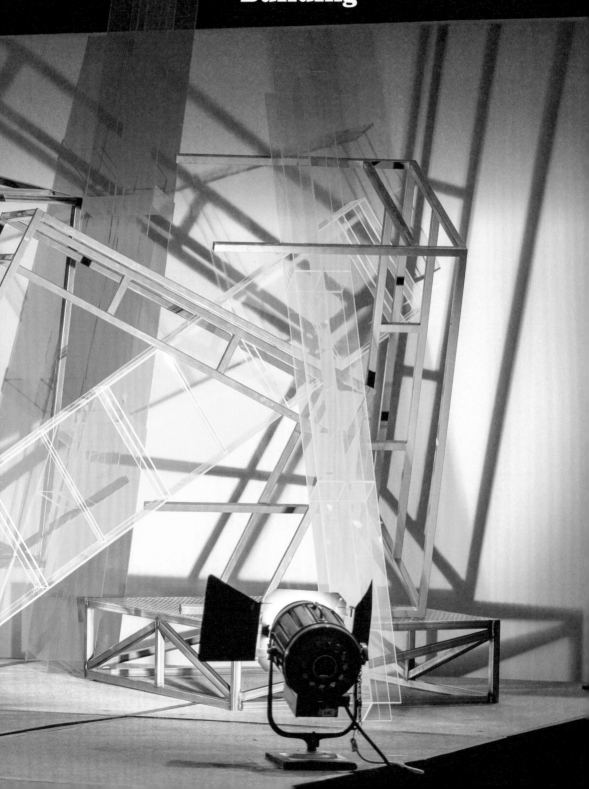

Adler and Sullivan, Auditorium Theatre, Chicago.
Chicago History Museum, HB-31105-C. Photograph by
William C. Hedrich for Hedrich Blessing, 1967.

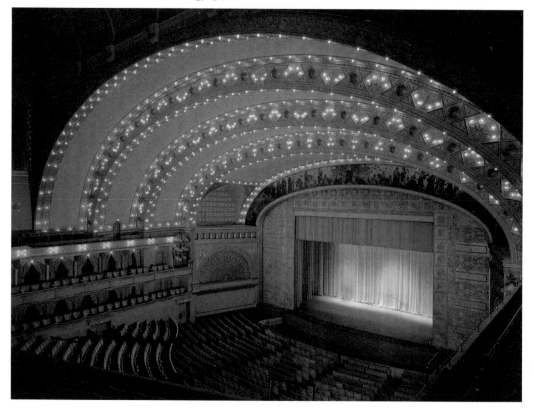

Author and cultural historian David Garrard Lowe interviewed by Studs Terkel (1975)

Studs Terkel **Now what was it about the [Auditorium] Theatre? Win Stracke, my friend, who was an architectural buff, always said something about the Auditorium, that it's, it's—I didn't realize that Louis Sullivan knew Walt Whitman.**

David Garrard Lowe Oh yes!

And that it had—it represented democratic vistas, any seat, it was a democratically organized theater.

Absolutely. He made a clear point that it would never be called an opera house because he thought that that was a snobbish, antidemocratic idea, and he built those great arches in it with gilt, plaster, and bulbs, so that every member of the audience would be wearing a tiara equally. He wrote that. I love that.

Every member would wear a tiara equally.

And he called it the Auditorium as a democratic phrase, not an opera house.

Of course, auditorium. To hear.

He wanted people to hear.

Where everybody can hear.

Hans Ulrich Obrist

It's now my immense pleasure to introduce our two next speakers, Jeanne Gang and Barbara Kasten. Please give them a very, very warm welcome. We are sitting on this stage, which Barbara Kasten has so very kindly designed for the occasion. I didn't want to speak about it until you were on stage.

I'm so grateful, Barbara, for this amazing work you created for the marathon today and I wanted to ask you to tell us about it, because it somehow connects also to Jeanne and to architecture. You said that it brings together Mies, Moholy-Nagy, and yourself.

Barbara Kasten and Jeanne Gang.

Barbara Kasten That's right. What you see behind me is an assemblage that's not welded together. It's a group of tables that are balanced on each other. The table bases are from Crown Hall, which is used as a studio for architectural students at the Illinois Institute of Technology. My concept was to honor these two great immigrants who came to Chicago and changed our landscape, as well as our art educational methods. Both of them were associated with the Bauhaus, which really had an impact on photography, which is one of my major disciplines. So I call this *Intervention*, and it's a merging of my sensibilities with theirs.

Obviously you often construct assemblages. I saw your 2015 show at the Graham Foundation, and often there are elements that are not fixed together. They're somehow in a provisional state, in a state of flux. Can you tell us what's behind this approach to space?

Well, I think it started because my photography is a recording of sculptural elements that I place in front of the

camera. Those elements are very flexible because I move them around to compose on the back of a large view camera, and I never make things permanent. They're all very flexible. As I continued with that process I tried to use the balance and construction that I think relates to architecture and the process of putting a building together. I think it's akin to the kinds of things you do, Jeanne. In fact, I'm much older than Jeanne, but I think had I been her age, I probably would have been an architect too.

There is a very architectural aspect in your work. In the 1970s you began building these large-scale models in your studio, and they were actually then photographed. What triggered that? How did that all begin?

How did it begin? I think it was because I got into photography with a series of photograms that I did, and to make those photograms, I arranged geometrically shaped objects on top of a light sensitive paper. That construction of objects to create the image is where I think it all started.

Barbara Kasten, *Photogenic Painting, Untitled 75/21*, 1975. Cyanotype, 30 × 40 in.

What would you say are the unrealized projects? I'm wondering, because many of your projects have an architectural dimension. Did you ever think of building buildings or building architecture? Do you have projects that are too big to be realized or too small to be realized?

No, I don't think I'll be in competition with Jeanne at all. I think, though, that I would love to work more closely with an architect to realize some projects, and now that I've been able to present sculpture for sculpture's sake rather than for a photograph, I think there are probably more possibilities that I can collaborate on in some way.

You were inspired, of course, by Moholy-Nagy and Mies, as we said initially. You were also inspired by a

lot of light artists from California. You told me that James Turrell was involved, and you said in another interview John McCracken. Also Craig Kauffman. Can you tell us a little bit about these influences?

Well, I think they were influences because I lived in California. There was plenty of sunshine, and there was a lot of experimentation with industrial materials by artists. I used photographic process to incorporate it into my painting. I didn't train as a photographer. I was into painting, and the whole idea of using cyanotype, which is how the photograms were made, was to see if I could find a merging of process that I could then apply to painting. So I didn't come to it from photography. I really was trying to make it part of a new way of dealing with painting.

You've always explored film and the moving image, and you've revisited them lately. Can you tell us about how that began?

Well, because I make these movable sets to photograph, and I use a light that projects colored shadow, if you move the light, it creates movement, of course. And what I did was record that movement, and display it. In the case of what Hans saw at the Graham Foundation, I projected the video onto a structure I had built with white geometric

Barbara Kasten, *Scenario*, 2015. HD color video with plaster geometric forms, 12 × 18 × 9 ft. Installation view from *Barbara Kasten: Stages*, Graham Foundation, Chicago, 2015.

shapes that were similar to the shapes in the video. With the video projected on top of it, it became a three-dimensional movement that occurred both in real space and in the illusion of a photographic video.

And what about geometry? Many years ago, I went to see César Domela in Paris. He was almost a hundred years old, and he talked about Mondrian not tolerating things that weren't geometric. He couldn't bear when even a matchbox was not at the right angle. You're also a perfectionist, and geometry plays a big role, so I'm curious if you could talk a little bit about geometry.

Well, if you had been here earlier and seen me trying to light this.... It's like move that over an inch! It's very much part of my nature to be a perfectionist. I'm seeing it through my eyes. You're going to see it through your eyes. It has to work from many different perspectives, but the one that I know is mine, so I make it to be the perfect vision from my point of view.

I have questions for Jeanne, but here is my last question for you: we've been talking about what is missing, what is urgent, what does Chicago need. How do you feel about that in 2018, living in this city?

I don't think it needs anything but more of what it's already done and been. I think we have been a very open city to immigrants and to people of talent from many different places, and I would just like to make sure that remains. Moholy and Mies were both immigrants. My grandparents were immigrants. That's a very important aspect of Chicago that I really would like to see continue.

Thank you very much. That leads us right to Jeanne. I wanted to ask you what is missing. What does Chicago need? Earlier I spoke with Eve Ewing about her very fascinating book *Ghosts in the Schoolyard*, about racism and school closings in Chicago. It's a very critical moment in this city. There is about to be a change of mayor. What does Chicago need? Where does Chicago go?

Jeanne Gang I think, in general, that the city is not connected enough. There are very disparate parts, and the people in different parts don't normally come into contact, and this is getting worse because of growing inequality. So we need something to glue us together again, to make us aware of each other and engaged with each other. Maybe that's too abstract. To put it another way, our city is kind of like outer space. Everyone is orbiting, and we need to have something big happen that brings us back together, that gives us a common cause.

Artists are known for having a social practice, and you are an architect who has a strong social practice. Basically, your buildings and visions always address larger social issues around public space or climate change. Yesterday, I was reading your book *Reverse Effect: Renewing Chicago's Waterways*, about the river and the boathouse in Chicago. I was wondering how you came to this particular way of being an architect and why it's important for you?

Jeanne Gang, *Reverse Effect: Renewing Chicago's Waterways* (Chicago: Studio Gang in collaboration with the Midwest Office of the Natural Resources Defense Council, 2011).

It wasn't something that was planned out ahead of time. It was just being who I am, along with the other architects who work together in our office as a collective. We use architecture as a medium to explore space and form, but we also see that it has the power to do something more. So we've tried to employ it as a way of thinking about the city and space, to help the city change and become what we want it to be, if that makes sense. It's a way of being in the world. How can we use our talents to enact things that we want to see—to be a kind of catalyst? Architecture has that ability. We also work on urban design projects, and what we've been doing there is thinking on a bigger scale, combining longer-term planning ideas with immediate short-term architecture and existing architecture, again with an eye toward catalyzing change. With the river, we were thinking really long-term. In the late nineteenth century, engineers reversed the flow of the Chicago River so that today, everything we put into the system ends up in the Gulf of Mexico. To really confront that environmental impact requires un-reversing the river. But making that major change begins on the individual scale, with helping people care about the river and feel ownership of it. This

was the idea behind the boathouse projects—to make architecture that could catalyze stewardship and a constituency around the river.

Studs Terkel talks about the importance of listening. How can architecture listen?

Listening is a really powerful tool for architects, especially for projects at the urban scale. Community-engagement skills like listening and interviewing aren't usually taught in architecture school, but they should be. We need to be able to ask people what they want to see in their community. There are amazing, surprising, great ideas to be found there. It felt natural to us to ask and listen to find out what those ideas are. Recently, we've been building our engagement skills in a more formal way, through office workshops led by a community organizer.

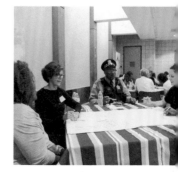

Studio Gang leading a community-engagement workshop at the 10th District police station in Chicago's North Lawndale neighborhood, 2015.

It's interesting to think of architecture as a tool for addressing social or environmental problems or issues. Can you give us an example of how a building can do that? Obviously buildings are very slow, so I'm interested in how we can introduce urgency in trying to address these issues?

The idea is that *what* we build matters, too. For example, in the past ten or fifteen years, a lot of major architects have devoted their work to cultural buildings and other large-scale, elevated projects. But I think there's a lot of design thinking that could come to everyday architecture. In our office, we always try to keep a certain number of community projects going in order to maintain that direct engagement—designing a boathouse, for example, or a community center. Those type of buildings are really the everyday change agents, so you don't want to lose sight of them amid other big projects.

As far as design goes, how can it be more accessible? How do you make people feel that they are empowered to be in a space? Those are some of the questions we ask ourselves in the course of the design process.

I thought that it would be nice if you could ask each other a question.

Barbara Kasten We in Chicago are lucky to have a couple of your buildings adding to our beautiful landscape. But you're a world-renowned architect. You have global projects. I wonder why it is that you stay here. Not why do you like Chicago, but why do you stay here as your main office?

Jeanne Gang That's a great question. One basic answer is that I started my practice here, and we've put down roots. It's a family and we're very connected in the community. But the thing that initially attracted me to Chicago was its legacy of building and construction, and that there was space here to experiment outside of the glare, let's say. Our studio still works on built experiments and collaborations with artists. It's very easy to do. We have a community of artists and architects here in Chicago that can connect, and we really like that part of it. Even though we now have offices in New York, San Francisco, and Paris, Chicago is the home office and the center that we all gather around.

Studio Gang,
WMS Boathouse
at Clark Park,
Chicago, 2013.

It has to be inspiring to young architects and young people that you are in your hometown and you don't fly off to New York. I mean you literally do fly to New York, but you don't take everything and go to the Big Apple. That's really a vote of confidence in who Chicago is and can be, and I think it attracts other people of your caliber, which is important.

Jeanne Gang Our architecture community isn't always geographically based, because you can connect with people without having to be in the same space. But there is this locus that we need. Physically, one thing that we like about Chicago is the ability to have more space to do bigger experiments— it's so easy here to do the making of design. We also think about Chicago's ability to support people who have different conditions in their lives. For example, if you want to start having kids, it's very hard to do it in Manhattan. So we've had migrations here from our New York office, and vice versa. It's nice to be able to accommodate different lifestyles.

> **Barbara Kasten** I totally concur about the ability to find space. As an artist, and one who aspires to do big art, it's very difficult to find space in some of the major cities I've lived in, LA and New York. Here it's accessible, it's affordable, and it's part of a community where you can have exchanges with young people. I really like that kind of thing.

Yeah.

Do you have questions for Barbara?

One thing we didn't get to touch on but that we share in common is this joy of working with materials and their qualities. I know you studied at the California College of Arts and Crafts, and I'm currently designing their new facility. I'm really interested to know if that interest in materials started there, and also if you could talk about how you think of material. How does it inform your work, and what makes you choose one material or another?

> I think we could talk about that for a long time, because materials are the genesis of what I do. They really inspire the form. I find a material that's interesting to me, and I try to push it to the point where it begins to tell me what it wants to do, and how it reacts. This material here, for instance, the colored acrylic, has a special quality where the edges glow. It's a material that was very popular in the 1980s but is no longer made in the same way or in the same variety of colors. When I found it, I found ways to work with it, both to photograph it and to use it in the set. Materiality is one of the most important aspects to my work, and to my process.

That could almost be the conclusion. I do, however, have a last question. I already asked Barbara about inspiration. Jeanne, we first met when you worked with Rem Koolhaas on the Bordeaux House. Rem was an inspiration, but a lot has been written about that. I wanted to ask you today about Lina Bo Bardi, because I think a lot of what has been discussed, what you've said about the local and the global, has somehow to do with Lina Bo Bardi. She in such an exemplary way brought together the local and the global. Can you tell me a little bit of what we can learn from Lina Bo Bardi for twenty-first-century cities? What can Chicago learn from Lina Bo Bardi? What can we all here, in the room, learn from Lina Bo Bardi?

Jeanne Gang That's a great question. She's one of my favorite architects of all time. As an Italian who emigrated to Brazil, she really embraced the local culture but continued to have that dialogue on a global level. A lot of her work is quite bold. It uses materials that are available and nearby, but always with a human connection. You see how the projects, especially something like SESC Pompéia, bring people together—almost exactly in the way that I was saying is missing now here in Chicago. In Brazil, there's a big disparity in economic status among citizens. You have very poor people, you have very rich people, and the SESC Pompéia project really brings everyone together with its cultural offerings, food offerings, intellectual offerings, physical offerings. It's just an amazing project, and it's a touchstone for me, as well as an incredible material construction. I would recommend looking at that project if you ever get to São Paulo.

Thank you both so much. It is magical, really an amazing experience, to sit here on and in Barbara's stage, which explores the relationship between art and architecture, and have your dialogue between art and architecture. A very big round of applause for Jeanne Gang and Barbara Kasten. Thank you very much.

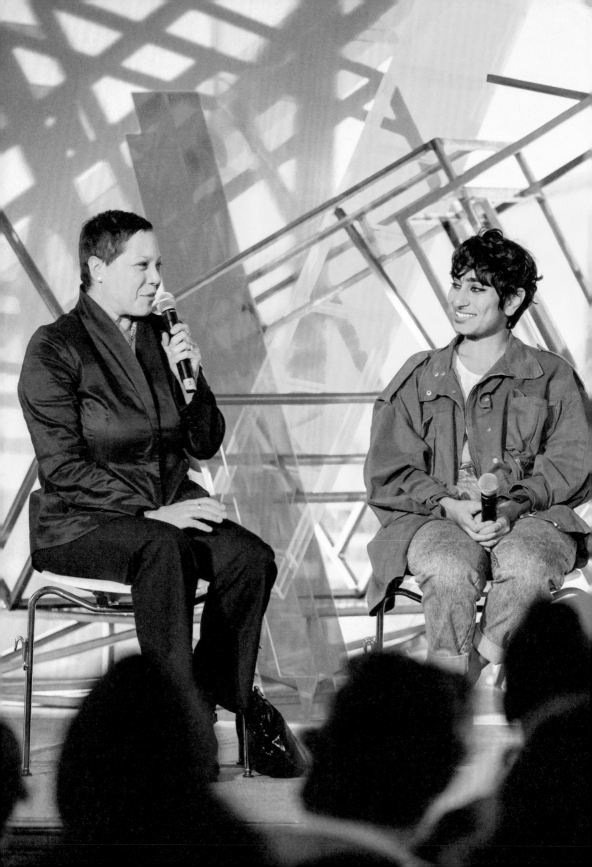

Hans Ulrich Obrist

It's now my immense pleasure to introduce our two next speakers, **Fatimah Asghar** and **Edra Soto**. Fatimah is a poet, performer, educator, and writer, best known for her authorship of *Brown Girls*, an Emmy-nominated web series featuring a friendship between women of color. Edra Soto is a Chicago-based interdisciplinary artist, educator, curator, and codirector of the outdoor project space The Franklin.

A very warm welcome to both. You have in common an engagement with many parallel realities. You both do lots of different things. But I wanted to start with a question to Edra first. Edra, you are an artist, an educator, a curator, a gallery director. You work in Chicago, but you were born in Puerto Rico and actually began your education there. I wanted to ask you a little bit about your beginnings. Who were your inspirations?

Edra Soto and Fatimah Asghar.

Edra Soto My upbringing in Puerto Rico is what has inspired my ways of thinking the most. Since my middle school days stepping into the playground, I questioned how we naturally segregate ourselves. I think about hierarchy—the invention of this—how we easily acclimate to a given structure. But the one thing that really directed me toward becoming an artist was being a really shy kid who had a lot to say. I figured that through art, I could say the impossible. I could reach beyond.

And your work continues to engage with Puerto Rico, and of course Chicago. I was thinking about the *GRAFT* installation, which featured iron

screens, or *rejas*, which became very present in postwar architecture in Puerto Rico. I was wondering how you connect the places.

Edra Soto, *GRAFT*, 2018. Wood and paint. Installation view, DePaul Art Museum, Chicago.

I lived in Puerto Rico for twenty-seven years. I've been in Chicago for twenty years. I usually talk about relationships in my work, and this has become the most natural relationship because I'm still between these two places.

The work that I'm doing now focuses on *rejas* (Spanish for fences), vernacular architecture that has allowed me to think about ways of occupying space. I think of it as a physical transplant or a form of migration. The patterns in *GRAFT* are representations of wrought-iron fences. I call it *GRAFT* because these are patterns that permeate my upbringing. I grew up in a house and a neighborhood that was surrounded by these patterns, and people live in them. One thing that is very curious to me is that there's no popular knowledge of the origin of the patterns—that really motivated me to research them. Eventually I created an extension to this project in literary form that allows me to bring forward not only my voice but the voices of people who are experts in their respective fields, like architects and poets and historians. I have even opened it up to artists, so there are artist manifestations related to the making of fences.

I also wanted to ask you about the project at the MCA, *Open 24 Hours*.

That's a marathon, and it's interesting because when we started the marathon at the Serpentine in 2006, Rem Koolhaas and I interviewed seventy-two Londoners, nonstop over twenty-four hours. We never left the stage, except for short breaks of five minutes. It began with David Adjaye and ended twenty-four hours later with the late Doris Lessing. In a way, it had a lot of to do with this idea of open hours, in that people could come and go at any time. Very often museums close at 6 p.m., and that's when people would actually have time, because they work until 6 p.m. It's sort of the paradox of opening hours. So I was very curious to see that you did a show here at the MCA that was open twenty-four hours. Can you tell us about that?

Edra Soto, *Open 24 Hours*, 2018.
Fine Arts Display Case, Chicago
Athletic Association hotel.

I use the title *Open 24 Hours* to describe visible refuse
in my neighborhood. There's excessive amounts of
garbage visible to all, every day. My impulse was civic—
I started collecting glass bottles because that was, and
still is, the most prominent type of refuse in my neigh-
borhood. Eventually I figured out that the predominant
type of bottle I kept finding was cognac, and I thought,
"Why cognac in this neighborhood?" My neighbor-
hood is a historically African American neighborhood.
Through research, I learned that there's a great history
that connects cognac with African Americans in the
1940s and earlier, when black soldiers serving in the
south of France during the world wars were intro-
duced to cognac. While African Americans were being
oppressed in the United States, their music and their
culture was being celebrated in France. Cognac became
a symbol of celebration.

Interestingly enough, besides living in Paris for a
year, I have in the past researched other subjects that
have connected me to France. The historic connection
between cognac and African Americans gave me a sense
of empathy for alcohol consumers in my neighborhood.
It's an evolving series. I've been doing different types
of series. I started by archiving the bottles I found,
because I think of these bottles as evidence of our reality.
I share the documentation on Instagram using the hash-
tags: #open24hours, #reintroductiontosociety, #stilllife,
#bychance, #civicaction, and #chicagoneighborhoods.

I wanted to ask Fatimah the same question I asked Edra first. What were your inspirations? What were your early influences? How did it all begin?

Fatimah Asghar I'm inspired by a lot of different things and a lot of different people. I feel really blessed that a lot of my inspirations came from my own peer groups. When I was in school, I was really inspired by my friends who wrote poetry with me. We formed a little group and continued to check in with each other after we graduated. And we made this thing called the Dark Noise Collective. There are six of us, and I'm super inspired by all the artists who are in that.

So who are the other members?

Dark Noise Collective.

Jamila Woods, Danez Smith, Franny Choi, Nate Marshall, and Aaron Samuels. Jamila and Nate are both Chicago artists too. When I moved to Chicago, I was really, really inspired by a lot of different types of artists here. I was inspired by the poetry scene here. I was inspired by going to galleries and seeing people. I was very inspired by Theaster Gates. There's a way that just living in Chicago and witnessing the way that artists were here, the way that artists would often take note of you even if they were on a much bigger level than you and encourage you, is really beautiful to me. And so there's a way that I find this whole city inspiring.

In an interview you quoted Jean-Michel Basquiat about influence: "Influence is someone's idea going through my new mind." That's beautiful.

Yeah, I love that quote from Basquiat. I think he's brilliant.

I was also wondering if you can tell me a little bit about *Brown Girls* and how that began. What was the epiphany behind this web series, which has become so well known?

I wrote *Brown Girls* after I had a dream. I had been interested in film for a really long time, but I didn't know how to get into it, and I was like, you know what? I'm going to try to write something and see what happens. So I wrote it thinking about my friendship with Jamila Woods and thinking about the ways in which I didn't really see a lot of representations of friendship between women of color that felt like my friendships. A lot of times when I would see two women on a screen, they were in competition with each other or at each other's throats. There wasn't a lot of seeing real friendship, and the ways that when you're really friends with someone, that is a relationship that, to me, is on a similar level with your love relationships or your intimacy relationships.

I really wanted to write into that love and create a little bit of space for that, and so I wrote it. I was coming from a background of poetry and really wrote it thinking about my own friends as the audience for it, and then was very surprised when I saw that a lot of other people connected to it, and that it just wasn't this kind of small thing that I was envisioning.

Your new work, *If They Come for Us*, is more focused on families, and actually your own family, your childhood, and the immigration experience. Can you tell us a little bit about *If They Come for Us*?

Fatima Asghar, *If They Come For Us* (London: One World, 2018).

Yeah, it's a collection of poems. The way I think about it is they're all different poems. A lot of them are about childhood or about sexuality or about my family. But ultimately, I think what it really tries to explore and interrogate is the idea of shifting identities and thinking about my parents' generation, which lived through Partition. They were born during colonial Britain's occupation of South Asia. So they were born as British colonized subjects. They were Kashmiri Pakistani, moved to England and were English, and then moved to America and were American. In an entire generation, you have all these really complicated

shifting identities. And it makes me think of how false the idea of a nation-state is and how false this idea of borders is. A lot of the book is about the falseness of borders, but also about how much stock we put into borders and nation and identity, and in a way that can be so trapping.

So it's an examination of history and the idea of what does it mean to really think about the historical violence that happened during Partition and that echoes on South Asian people to this day.

You both use the spoken word and publish your poetry as books. Following up on what Joseph Grigely was talking about, the spoken word and the written word, I was wondering what it means for you. Do you have a preference? Is creating poems to be spoken into the mic different from creating poems for the page?

I think that for me, all my work is to be read out loud. I believe in that moment when you read a poem out loud and you connect with an audience. I believe in that moment because it's a kind of dialogue, and I think the best poems work when they can be read out loud and on the page. And so even though I have visual poems in my book, I still read those out loud. I like both, and being able to do both is the way I think of a poem.

So both/and instead of either/or.

Now, the question of unrealized projects. I want to ask you both about your unrealized projects. I know that you actually, Fatimah, have an unrealized museum, an imaginary museum that would be dedicated to your parents and family in Kashmir. Can you tell us about that, about your unrealized project?

Yeah, that would be beautiful. I think that when you're an artist, so much of your trying to find something is like a deep exploration, and finding things that are half-truths and trying to make up what happened in between. Sometimes I wish that somebody would just give me that information. My parents died when I was really, really young, and so much of my art is an attempt to find a little bit of home with my parents. And with Kashmir, where my family is from, being an occupied territory, not really being its own thing,

I'm trying to carve out a little bit of space for that. But I have so many unrealized projects. There are so many dreams that I want to pursue, and so many things that I'm really interested in, so many collaborations I want to do. But I find them really inspiring, because even if someone has told you no, that doesn't mean no forever. Especially in art, you get rejected all the time and I think about a "no" as kind of a "not yet," just waiting until the moment where you can do the thing that you want to do.

And what about Edra's unrealized project? Projects that have been too big to be realized, or too small to be realized, or censored, or self-censored, dreams, utopias—the whole roster of the unbuilt. The unbuilt Edra Soto.

Edra Soto Well, growing up in a middle-class culture influenced by American culture and looking at the life that I have forged for myself, I think about that as the ideal place actually, where you find satisfaction just in the simple things.

Last question to both of you. It's the question of what is missing. What does Chicago need? What is urgent?

I think of gun violence. Violence in the neighborhoods is an important issue that should continue to be assessed. And education, focusing on the children's needs rather than on the differences that administrators always focus on.

Fatimah Asghar I get really worried seeing things like so many school closings. It's deeply worrisome the way sometimes the government fails its citizens in Chicago, closing down public-housing structures and displacing people without giving alternative backups. There are so many ways that I've seen the people of Chicago rise and the government not do shit. That's really frustrating. So what I would hope for is politicians who actually care about their citizens and who actually can listen to activists and listen to organizers and really make ways to create the change that people are asking for.

That brings us back to listening. Fatimah, Edra, thank you very much. A big applause. Thank you.

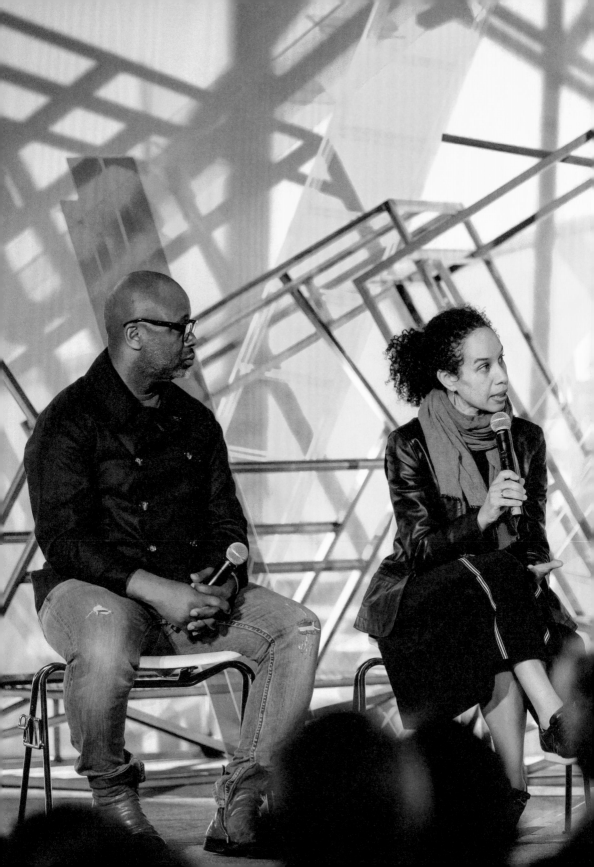

It's now my immense pleasure to introduce our next two speakers, Louise Bernard, the founding director of the Museum of the Obama Presidential Center, who previously served as director of exhibitions at the New York Public Library, and Theaster Gates, who needs no introduction here.

Drawing on his training in urban planning and preservation, Theaster creates work that is *the* social sculpture of the twenty-first century. A very warm welcome to Theaster, a very warm welcome to Louise.

I wanted to begin by asking Louise a few questions. I want to ask you how you came to the world of museums, and how you came to designing and developing exhibitions. What were the formative experiences on these paths that made you decide to use this medium?

Theaster Gates and Louise Bernard.

Louise Bernard Thank you, Hans. It's wonderful to be here. I've had a relatively circuitous journey, I must say. I was born and raised in the north of England, and I came to the United States for graduate school and basically never left. Originally, I was at Indiana University Bloomington, studying theater history and then English literature. I left and lived for a year in New Orleans, and then eventually went to Yale, which is where I did my PhD, an interdisciplinary degree in African American Studies and American Studies. I was always really interested in the idea of cultural history, and the way in which African American Studies is actually the story of modernity itself, is the story of the African diaspora, of movements of peoples, the birth of cultures.

Then I did follow a traditional tenure-track path. I went to teach in the English department at Georgetown. I was teaching American literature, African American

literature, postcolonial literature, but then had the wonderful opportunity to go back to Yale as a curator at the Beinecke Rare Book and Manuscript Library. Through my colleagues there in Special Collections, I learned everything I know about curating. Then I had the opportunity to join a museum design firm, so I went to Ralph Appelbaum Associates to work very specifically on content development—a field I knew nothing about—for the National Museum of African American History and Culture. And I was the lead content developer for the History Galleries, for the Cultural Expressions Gallery, for the Military Gallery. So then I was really thinking about the relationship between museums, the archive, public history, how to make a very complicated history digestible for everyday people, and how to bring it very physically to life. It's about the relationship between a certain kind of textural narrative and built space, and bringing those things together.

I then returned to the world of the archive: the New York Public Library, which is a really wonderful research institution. I was still thinking about the museum, the archive, the public library, and then had the opportunity to come to the Obama Foundation, now as the founding director of this new museum project. So I'm back at that point of really thinking about what it means to build a museum from the ground up, a museum of the twenty-first century and a museum for the future.

Of course, you're working very closely with Barack and Michelle Obama on this new institution, and as far as I understand, this is not going to be just a museum. It has to do also with agency, and the production of reality, something we're also going to discuss with Theaster, in terms of his practice. So it's not only about looking back. It's also about looking into the future. Can you talk a little bit about this? Because it seems to be very different from what presidential libraries usually are. It seems to be more oriented in terms of something that produces reality.

Absolutely. We do tend to think of presidential museums as being about a very particular time in history, and they generally present the story of the "great man," a celebration of a particular presidential administration. In terms of the

Tod Williams Billie
Tsien Architects, model
of the Obama Presiden-
tial Center, viewed
from the southwest.

Museum of the Obama Presidential Center, we certainly
want to tap into that particular understanding, honoring
and celebrating the first African American president, the
first black family in the White House—a White House that
was built, as Mrs. Obama has made very clear, by slaves.
We're really thinking about what that story means. But we're
also thinking about this particular museum, that particular
narrative, and its ability to inspire and to empower and to
connect future generations of leaders. And when I speak of
leadership, and the very idea of a leader, I mean that in the
broadest possible sense of the word. It's really about revital-
izing and supporting and building upon this very particular
place, which is in historic Jackson Park, on the South Side
of Chicago. So it's rooted in that familiar narrative. And it's
simultaneously about the importance of that watershed,
pivotal moment in American history, but also what it tells us
about the power of possibility. It's about the past, the pres-
ent, and its relation to the future.

**I'm interested also in how this connects to your experi-
ence previously with the National Museum of African
American History and Culture in DC, because you were
part of the team that developed that museum. What
will you bring in from that experience?**

Well, I think there's a connection in terms of thinking about
these iconic moments, and the power of African American

Obama Presidential Center
ideation session.

history to really tell the story of America. You can think about the history of that particular museum, which was a hundred years in the making. You can think about its iconic place on the National Mall, with its immediate adjacency to the Washington Monument. And then think about parallels in terms of the great city of Chicago, the history of Jackson Park, this museum, this center's adjacency to the Museum of Science and Industry and its going back to the Columbian Exposition of 1893—there are layers of history.

But one of the key takeaways from the National Museum of African American History and Culture is the fact that the history itself means so much to people. I was there as a liaison between the design team and the curators at the Smithsonian, really working to translate this four hundred years of history into a physical experience. The amazing thing that I've witnessed over time is just observing people who visit, and the intergenerational connection to the stories. I've seen families, great-grandchildren in strollers with their great-grandparents in wheelchairs. I've seen people who spend an entire day at the museum. As many of you will know, museum tickets for peak times are sold out months in advance. The dwell time at a Smithsonian Institution museum is usually about two hours. But at this museum people often stay four to six hours. I've seen parents reading the label text aloud to their children. I've seen groups of teenagers reading stories aloud, communing with the objects, so to speak. There's this sense of pilgrimage.

And I do imagine there will be the same kind of underlying sentiment in terms of this particular place. Because we have to recognize that many people—by which I mean African Americans of a certain demographic, of a certain age—did not think they would live to see that day, when an African American president would be manifest.

Maybe a last question about archives. You have this experience with archives, and earlier Joseph Grigely told us about the importance of archives. We've just seen the film of Cauleen Smith, who's a great example of an artist who, in an amazing way, produces reality using archives, bringing them to life. Can you tell us a little bit about this idea of archives as part of the Obama Center, and how you're going to make archives dynamic?

There's an emphasis, particularly, on the object. But there's a power in terms of archives as we think of them in relation to special collections, by which I mean printed material, printed matter, the work of the manuscript. I think there's something empowering about seeing the hand, the haptic, the written word on the page. To see President Obama's own handwriting as he's drafting speeches, and to think about the power of those speeches to move people, the work that went into it. We also think about President Obama himself as a reader, writer, thinker. He's an intellectual. He's someone who comes out of a deep embrace of knowledge and its production. And I think this is what the archive is about. It's about that trace, and that connection between historical figures both known and lesser known. I think that's the work that Theaster is also doing through the archive, embracing and bringing to life those people who may have otherwise been forgotten.

This leads right into your amazing work, Theaster, with archives. Because so much of your process has been informed by archives, by collecting forms of culture, by providing spaces for them to be honored, by giving people access to them, by making it accessible for everyone. From the LPs of DJ Frankie Knuckles to the whole back catalogues of *Ebony*, which are such seminal publications of the African American

experience. I was wondering how you came to archives and how that entered you work, and if you can tell us a little bit about the importance of archives for you.

Theaster Gates I went to middle school kind of on the North Side of Chicago, and in this area on the North Side of Chicago there were a lot of thrift stores. I wanted to wear nice clothes, so I would go to the thrift stores so that I could find nice clothes for really cheap. I would spend a lot of time rummaging through things. Like, in my waist size, trying to find the right pair of bell bottoms, or trying to find the right knitted sweatshirt that would be super cool and nobody else would have it. And I think something about hanging out in thrift stores prepared my eyes to hone in on things that were particular or peculiar, or things that I liked. It kind of sharpened my eye. I would say, in some ways, thrift stores are the archives of America. You're constantly looking at other people's things and the things of the past. In some ways, me wearing those things was the first opportunity to reactivate things from the past. I never thought about the thrift store as an archive, but if I were to try to find a moment, it seems like the thrift store became the link that got me from my personal desire to wear hip clothes in the late 1980s and early '90s, to recognizing that the clothes that I was wearing were continuing a legacy. It was keeping clothes out of the dump. It was allowing me to take on a persona through a set of things that maybe I couldn't quite afford. Because the Hart Schaffner & Marx suit was way more expensive than I could afford, but in fact I could embody things that I couldn't afford.

I was wondering also who were or what were your inspirations to start all of these projects. I found an interview where you said Margaret Burroughs was important for you, and the DuSable Museum. But you mentioned also other examples, the Rosenwald Elementary Schools around the South, the Carnegie libraries. Can you tell us a little bit about what inspired you?

It was becoming evident that there were very few opportunities outside of places like the DuSable Museum or the Schomburg Center in New York—that there were very

few places acting as repositories for black things. At the same time, I was spending more and more time on museum boards where people were donating things all the time. They would donate their Warhols, their Miros, their Louise Bourgeois. And I was on accessioning committees where things were being brought to libraries. And I just thought, "Man, one way to make a Rauschenberg special is to take it out of the private space and move it into the civic space." But often black objects would live in private spaces, and when the lives of those spaces ended, they would die. And so, could we start to make civic spaces that were for the private things of black people? Because that's been an ongoing relationship, from private to civic. I thought maybe if there are not enough of those repositories, I would simply practice making the repository. At first they were kind of wonky, like an old house. There's no heat, there's no air conditioning, but the house could be for something other than my living. In some ways, we just tried to honor and celebrate things better and better, and that eventually led to the creation of the Arts Bank.

Whenever I'm in Chicago, I visit your ever-evolving social sculpture, and I think it's a form of urbanism. It's interesting because it engages the question Alison raised in her introduction: could art be a form of urbanism? Before, Louise, when you described the Obama Center—I found this quote of President Obama, where he said, "It's not just the building, it's not just the park. Hopefully it's a hub where all of us can see a brighter future for the South Side." And that, of course, is a form of urbanism. I'm wondering if you could talk a little bit about that, about this agency artists have to really change the city. I asked you yesterday who should be the next mayor of Chicago, and what should happen to Chicago in terms of politics, and you said, that's one aspect, but at the same time whoever is mayor, you will continue to produce reality.

One of the things I learned from Barack's administration was that if he was to demonstrate generosity, the nation would mimic generosity. If he was to demonstrate a kind of sophisticated approach to caring about other nations, other people would also have empathy. And that demonstration

Stony Island Arts
Bank, Chicago.
Restored in 2015 by
Theaster Gates's
Rebuild Foundation.

has become an important part of my conceptual work.
When I started doing work on 69th and Dorchester, not a
lot of people wanted to live there. Some people were there.
But I found through the demonstration that black space
mattered—by demonstrating that over and over again, and
having a commitment to that—people all over the country
were like, "Hey, I like what you're doing. I want to do that
in Kankakee, Illinois. I want to do that in Jersey. Or I want
to do that in Kentucky." So I think that part of what I was
doing was just demonstrating what a black future could
look like, built by black people, so that more black people
might build it. And yes, it might be a form of urbanism.
But even if we lose all of the jargon, it was the activation
of abandoned space and the use of my energy to try to
do something that might change the conditions of a place.
And when one exerts energy, things change. It's really
simple. It doesn't require a tremendous amount of money.
It doesn't require a whole lot of political networking. It
just requires that you work your ass off. I think I was just
demonstrating how to work. Dorchester's a by-product of
that. It's just work.

**You've produced a lot of reality. I was wondering
about other projects that are unrealized, dreams, pro-
jects that have been too big to be realized.**

I would say I'm, like, 30–70, wins to losses, you know what I mean? I have to admit that if this was a business proposition, maybe most people wouldn't do most of the things that I do. But it's not a business proposition. It's a proposition that is trying to simply say, "Oh, if I try a thing, I might be able to change a thing." Or if my ambition is beauty, that beauty might appear. I think that the bigger project is I wish I had five hundred buildings that I had restored instead of fifty. I wish it were a two-billion-dollar investment on the South Side and the West Side, rather than sixty million. I hope that I'm getting better at playing in the sandbox, but I also think that I no longer have to play by myself. Some of this is about what can we do together. If I put my money together and my buildings together with other friends, can we collectively do more? And that sounds like citizenship, or cooperation, or society, humanism—that we would do things together, to make things better.

I've got a last question. We spoke earlier with Eve Ewing, who wrote this amazing book, *Ghosts in the Schoolyard: Racism and School Closings on Chicago's South Side*, which is about the disappearance of many schools. I wanted to ask you what is missing. What does Chicago need? It's a question to both of you. What is urgent?

Dorchester Projects, Chicago. Restored in 2008 and 2009 by Theaster Gates.

Johnson Publishing
Company books and
periodicals archive
at Stony Island
Arts Bank, Chicago.

Louise Bernard It's interesting for me to think about because I'm a recent transplant here. I just moved from New York, and I'm still learning about the city. What is evident is that there are already these amazing initiatives on the ground. There's a history. There's a desire to make change. But we are aware that the city is intensely segregated, that the neighborhoods are separate enclaves, so to speak. So, what is missing is all of the infrastructural undergirding to bring people together, but then the desire for dialogue. I think it's about the work on the ground that can forge that dialogue to go forward. And it's about empathy. It's about listening, to go back to Hans's point earlier, and to go back to Studs Terkel's archive.

Theaster Gates There are moments when, in order to solve a problem, I feel like you have to pull from lots of different professions and locations. In some neighborhoods, if there's a problem with the school, you have a lawyer, you have a former school principal, you have a series of activists, you have businesspeople, who all live in the neighborhood and they can work together. And they might have time to cause change in their schools. What I've sometimes noticed in the neighborhood I live in is that people are so occupied just living that we don't have the same voicefulness, because we

don't have the time and the extra resources. I think part of the challenge of a segregated city is that all of that shared intellectual and social resource that could be spread around, it's posited in pockets, and there's not a lot of friendship from one neighborhood to another. And so I keep thinking, what are ways that we could create more friendship, rather than anxieties about gentrification or neighborhood change? If people were just more interested in what happens on the West Side or what happens on the South Side, there could be more allies and advocacy to make things happen. I think friendship is missing from the city.

It could not be a more wonderful conclusion. Louise and Theaster, thank you so much! A big applause!

Post-it Note,
Theaster Gates.

Hans Ulrich Obrist

It's now my great, great pleasure to introduce our next guest, Dawoud Bey, who is a photographer and a 2017 MacArthur "genius grant" recipient. And for the list of urgent books, I would like to mention Dawoud's extraordinary new book, *Dawoud Bey: Seeing Deeply*. Welcome Dawoud.

We always begin with the beginnings, and I found in an interview you gave that your decision to become an artist happened because in 1969 you went to the exhibition *Harlem on My Mind* at the Metropolitan Museum of Art. I wanted to ask what you saw there and how it affected your ideas about what it would mean to be an artist.

Dawoud Bey.

Dawoud Bey Well, my beginnings, I guess, are in New York, in Harlem, where I didn't live, but where my mother and father met. And my first critically conscious awareness of photography as something other than pictures in a magazine or a newspaper came when I was sixteen years old and went to see the *Harlem on My Mind* exhibition. I didn't go to that exhibition because I was interested in photography. I went to the exhibition because there had been considerable controversy around it, and I had been socially and politically engaged from a very young age.

Without going into too long of a history lesson and lecture, *Harlem on My Mind* was an exhibition at the Metropolitan Museum of Art about the Harlem community, which of course by that time was a largely African American community. And one of the dominant issues had to do with the fact that, in the construction of this exhibition about an African American community in New York, there had been very little active input from the Harlem community. And then add to that the fact that it was 1969, a moment in which institutions of all kinds were being

Dawoud Bey, *A Boy in front of the Loew's 125th Street Movie Theater*, 1976. Gelatin silver photograph, 11¹⁵⁄₁₆ × 8¹⁄₃₂ in.

challenged, a moment when institutions and power structures in this country were being spoken back to. So that controversy and that conversation is what drew me to want to see the exhibition.

I'd never been to a museum at that time, other than the usual class field trips. Going to that museum on my own, walking in and finding the exhibition—it was a very intimidating experience. So much so that I didn't have the wherewithal to ask the information desk where the exhibition was. I just walked around the museum, pretending that I knew where I was and hoping I would find the exhibition, which I did. It was a very transformative experience. Seeing photographs of African Americans on the wall of a museum, and seeing people giving these photographs serious consideration, began to give me a sense of what I might do with the camera that I had actually gotten from my godmother the year before.

So for me, coming to photography and coming to the museum at that particularly contentious moment pretty much shaped the way I thought about making work and the kinds of institutional engagements or interrogations that I've tried to engage in through my work. It all goes back to that moment of contestation, and seeing the works on the wall. And the ironic thing about it is there were picket lines at the museum, and on the day I showed up, there were no picket lines. So I think it was meant for me to go in and see the exhibition.

And, of course, it then leads to your own exhibition, actually in Harlem, in 1979, your legendary series *Harlem, USA*. The other day I did a long interview with Faith Ringgold, who of course grew up in the Harlem Renaissance and was talking about the complexity of that multilayered history. Can you tell us a little bit about your *Harlem, USA* project, which is here in Chicago in the collection of the Art Institute? It would be great to hear about that seminal work.

Harlem, USA was a direct extension of having seen that exhibition at the museum, and wanting to engage in a conversation around the ways in which the black urban subject has been represented within the histories of photography, mostly through a lens of social pathology. Because I had

family in Harlem, and I knew that those representations were not true to the experience of the people living there, I wanted to make work that was a response to that. So that became my first group of works, and because of this tension around the community and the institution, when I completed that work, I wanted it to be conspicuously available to the people in the photographs. I had my first exhibition of that work made in Harlem at the Studio Museum in Harlem.

All of this early work happened in New York City, and then you moved to Chicago. How did that change your work, and what was different about being an artist in Chicago?

Well, I've been in Chicago twenty years now. I came here to take the position that I still have, teaching at Columbia College Chicago. I think that for me, even before coming here, Chicago had occupied a place in my imagination, going back to the late 1960s, at the height of what you might call the black cultural revolution in America.Chicago was one of the places that would have been considered kind of ground zero at that moment, so for me it held a lot of history. But I also had family here; I already had that connection to Chicago.

Then I started exhibiting here in Chicago, at Rhona Hoffman Gallery, which began to introduce my work to another piece of the various art communities. And I've continued to show my work at another gallery here in Chicago, Stephen Daiter Gallery.

In terms of how Chicago has impacted me, it has more to do with, I guess, the profound way in which the city has embraced me. I have felt wonderfully embraced by a very broad community of support. Coming from New York, I wasn't exactly sure how that was going to play out.

When I was a student in Paris, one of the first photographers I met was Cartier-Bresson, and I asked him about the role of a photographer. He started to talk about the idea of a hunter, which sort of seemed to lack empathy, and in a strange way also maybe he didn't really listen, or didn't have a conversation. He said, "A photographer is a hunter who at the same

time is a vegetarian." And that made it a bit better, but still it was awkward. You have a very different style of photography. There is empathy. I believe deeply that we need more empathy in the twenty-first century. Listening is key. Not loud manifestos, but listening to the world. And you've done that a lot. You're listening to the subjects you photograph. You often bring their voices into the work. Can you tell us a little bit about that, about empathy in the process of being a photographer and also listening to the subject?

Dawoud Bey, *Untitled #1, (Picket Fence and Farmhouse), from Night Coming Tenderly, Black*, 2017. Gelatin silver photograph on mount, 48 × 59 in.

For me, this quality of empathy has to do with the belief that the work can have meaning both in the object sense and in the conversation around, in my case, the making of photographs, the whole history. But it also has to do with the belief—my own personal belief—that the work we make can have what might be called a moral imperative. And that moral imperative plays out in a lot of ways. I think for me, initially, that began not even necessarily with photography, but in the music of John Coltrane. John Coltrane was very articulate, and he always said he wanted his work to be a force for good. And I think that's the first time I began to realize that the work could be rigorous—the work could be forward-looking and ambitious—and that it could also

have a moral dimension, could be a force for good, and that those two things could coexist in a meaningful kind of art practice. So that of course extends to the subjects I've made work with and about. This idea that my engagement with them comes with a certain set of responsibilities, both responsibilities to the subject and responsibilities as an artist wanting to make works that advance the conversation about art-making and what we might call, in photography, picture-making. But to not lose sight of what makes that meaningful.

The marathon, of course, is all about junction-making. It's about bringing people together. It began strangely, when we first started in 2005 in Stuttgart, because I had been invited to stage an event in a theater festival, and I said, "I really don't know what to do in a theater festival." So we did conversations, and then we started to systematize it at the Serpentine, but the aim was from the beginning to create junctions between people who had never met. It was fascinating that again today, most of the speakers in this marathon had never met. They all met in the green room, and I hope it's the beginning of many new conversations and dialogues. And of course the same is true for all the participants who are in the audience. When we do art lectures, the art world shows up. When we do architecture lectures, the architecture world show up. When we do a science talk, the science world shows up. With the marathon it creates a crossing of audiences, and that's why it's important that at the very end we have drinks and then, hopefully, you'll all meet each other.

Dawoud Bey, *Kathy Anderson and Jarrett Lampley, Hyde Park, Chicago, Illinois*, 2012. Pigment print, 40 × 32 in.

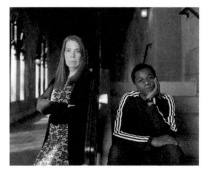

Now, Dawoud, your project _Strangers/Community_ has a lot to do with that. I was always inspired by this piece of yours because you wanted to bring together two people from a given community who did not know each other, and who would never have come together without you. Can you tell us about that?

Well, I think we often speak of community in a very essentialized way. Like, "We need to do more for the community." Or "We need to be more engaged with the community." You know, *the* community. When in fact there are multiple

communities. And even within the construct of particular communities, there is a kind of engineered social stratification—certainly within a city like Chicago, you know, which is very segregated by design. So what I wanted to do with that project was to question this notion of community and the fact that within that construct of community, there are for any number of reasons people who never engage with each other, although they're part of the community. I wanted to use the work in that project as a place where people from a particular community who had been self-segregated or segregated by social design could momentarily be brought together in some space within that community to jointly bear witness to their common sense of community-ness, and to use the work as a vehicle for making these kinds of introductions between people that don't otherwise happen because of the way communities are very often structured to keep people apart. The janitor may never meet the people who live in the apartments in the building. All communities contain social hierarchies that determine who will actually interact and who will not within that social space. The work was a way of responding to and visualizing that, and also served as a platform to transgress that and to bring people together for a common sense of witness.

Beautiful. Two very quick last questions: I wanted to ask you about an unrealized project. Your dream, or a project that's just too big to be realized, or too expensive, or has been censored or self-censored, or a project you didn't dare to do. There are many reasons a project could be unrealized. What's a project you would like to do but haven't done yet?

Well, right now I'm engaged in projects that have to do with how to visualize history, how to make visible things that are invisible, things that are in the past, how to make them visible in the present moment. So that is my current work, which at the outset seemed very difficult to visualize. But I've now been able to figure out the conceptual construct that allows me to create a kind of, I guess you would say, limited experience where the past and the present moment come to exist in the photographic object. I'm really looking right now and thinking about history, in particular pieces of the African American past and how to make those resonate in this moment.

Post-it Note,
Dawoud Bey.

**Very last question. If you look at Chicago in 2018,
the city here, what is missing in Chicago? What does
Chicago need? What is urgent?**

Well, I've been here twenty years now, and for me,
Chicago certainly is socially a very raucous place. It takes
its politics very seriously. But the thing that has been
most notable for me, being a transplant to the city, has
been the really embracing sense of community I have felt,
and by that I mean community in the broadest sense.
That doesn't by any means diminish all of the social ten-
sion that still exists in this city. I think I would just leave
that there. Because for me, it's been a very warm kind
of experience since coming here.

**Thank you so much. Another very big round of
applause for Dawoud Bey.**

Performance
Shani Crowe

Hans Ulrich Obrist As we said earlier, with the marathon there is always work, which includes readings, films that are produced for the occasion, and also live performances. We are very delighted now to introduce Shani Crow's live performance, which has no title. Shani is an artist whose work centers on cultural coiffure and adornment and beauty rituals as they relate to the diasporic African, and how these practices function as tools to facilitate connectivity. So again, the notion of fostering connectivity, which is very much at the core of this marathon.

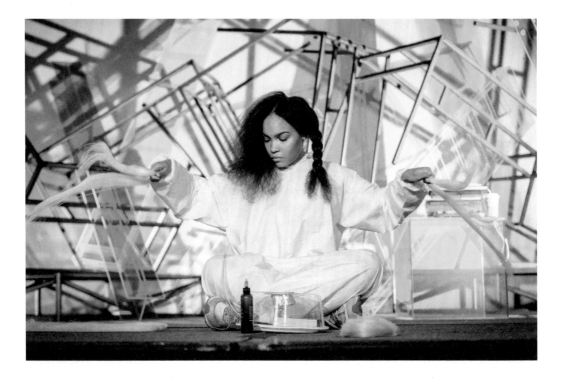

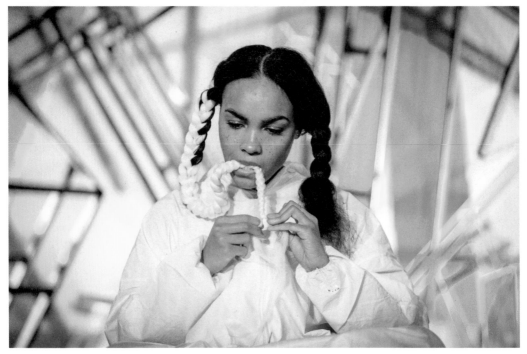

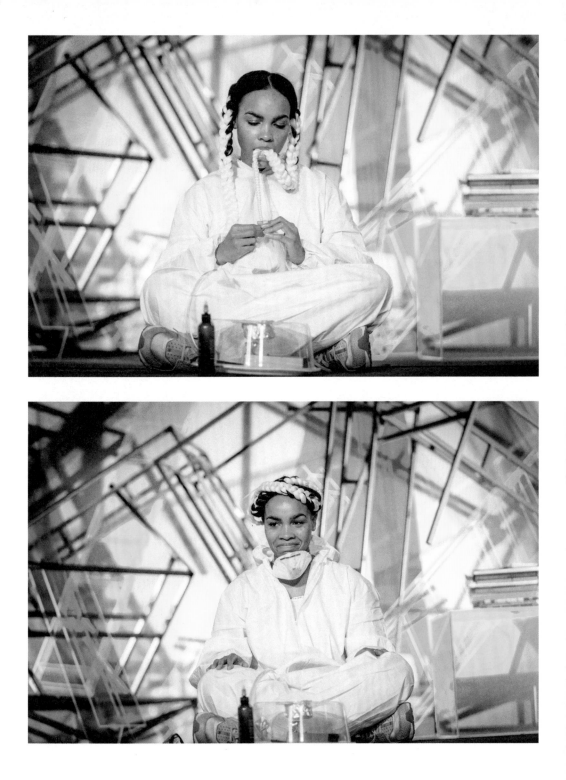

Act IV
Vanguard

Studs Terkel, 1969. Chicago History
Museum, ICHi-102948. Photograph by
Raeburn Flerlage.

Studs Terkel interviewed by Hans Ulrich Obrist (2006)

Hans Ulrich Obrist I read your books as books about polyphony. I think it's almost like in Dostoyevsky, that you do not give priority to one protagonist. Each one is a hero. I wanted to ask you as one of the last questions if you could talk a little bit about this notion of polyphony.

Studs Terkel Well, I think, who is one? There is no one single person who is a protagonist in my books. They are all people who survived a certain moment, one way or another, no matter what side they were on in the Good War. People survived a traumatic moment, the Great American Depression. There is no one person. Arthur Miller spoke of that one book, *Hard Times*. He says this is not only about it, this *is* the time. This is—when you read this—the most traumatic moment in American history since … the Civil War and the Great American Depression, when our society fell on its face. So it's gotta be polyphonic. It's got to have a collective of heroes and heroines. It can't be one. There are certain ones that stand out in *American Dreams: Lost and Found*. The title, by the way, is a takeoff on the hymn:

> *Amazing Grace, how sweet the sound*
> *That saved a wretch like me*
> *I once was lost, but now I'm found*
> *Was blind, but now I see*

And so, *American Dreams: Lost and Found*. There I have an ex-member of the Ku Klux Klan, the Grand Cyclops of Durham, North Carolina, C. P. Ellis, who becomes transformed as he finds out bit by bit. And he becomes a leading civil rights advocate in Durham. The man who was a former grand cyclops. He's got to be in it! It's about transformation, you see. Or transcendence! And so, that's part of it, too. There's no one. He could go into the heroes of the book, so could the black woman.

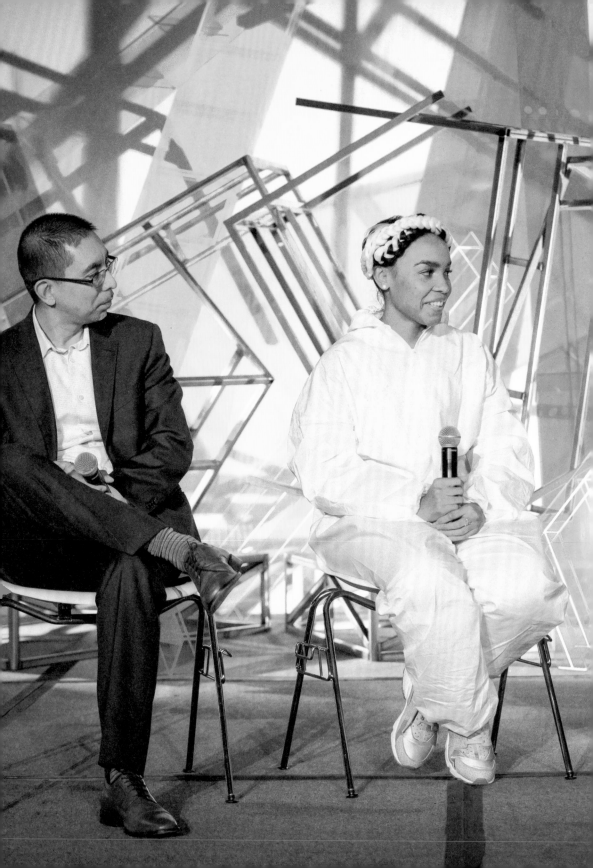

Hans Ulrich Obrist

I would like to welcome Shani Crowe onstage, together with Eddie Bocanegra. Eddie is the senior director of the READI Chicago initiative at Heartland Alliance, a role that allows him to parlay his own experiences as a person with a criminal record into mentoring and outreach to organizations, to community groups, and to at-risk individuals. A very warm welcome to Shani and to Eddie.

I've got many questions, but before starting, I wanted to ask you, Shani, to tell us a little bit about the background of the performance.

Eddie Bocanegra
and Shani Crowe.

Shani Crowe Well, this performance is really ritualistic self-care. For a lot of people, their day-to-day struggle doesn't really allow them the time to take care of themselves the way that they should. So, because I also am guilty of that, I ritualized it and made it a performance, so I have to take care of myself in order to perform my duty, literally. I anointed myself with oils, massaged my scalp, which is something that black women do. And I smoked myself out with palo santo and sage, which are used for smudging, for clearing energy. And I also really wanted to kind of protect myself. There's so much happening in the world, and for creative people I think it's important to stay grounded and not allow all the things that are going on to really penetrate your being, because that could be detrimental to your art, which is your livelihood. So it is ritualistic self-care and also kind of a protection deal.

You're an artist who works in a variety of media. There are films, there is photography, there's

painting, there's also pottery. But the work which has become most internationally known are these very complex, intricate hairstyles. And you then also capture these hairstyles as photographic portraits. I was wondering why you chose braids as your medium, in conjunction of course with photography.

I've been braiding my entire life. It's a skill that I've had since I was at least five years old, and it was something I saw as a trade more than an art form. As a black woman, hair braiding is kind of commonplace in the community, and we begin to undervalue some of the things that are really important to our culture. Unfortunately, other cultures will be like, "Oh, that's dope," and then put it in *Vogue* magazine or on the runway and rename it. And then you're salty, like, "Dang, those were just straight back braids, not boxer braids." I think it's really, really important for black women to claim the artistry and the passion and the love that goes into things that we do, for our own appearance and for others'. Because it's the way that we take care of ourselves and our hair. It's the way that we show love to other people, and it's a cultural connection that expands all over the diaspora for centuries. It's important for us to value those things ourselves.

It's interesting because of course these skills are preserved from generation to generation. It's a practice that has actually a very long duration, a longer duration than many objects, because it's something that is basically continuing and continuing. You said that you learned how to braid by watching your aunts and your cousins. Can you tell us a little bit more about this generational transfer?

When I was younger, my aunts would braid my hair, and I had a cousin who would braid my hair, and I always saw it as almost a rite of passage, to be able to beautify somebody else. I saw that as a great privilege, but it was something that I experienced in my family. And so many other people— you see people getting their hair braided on their porch. It was just a part of the community, and it goes back. Every black woman has been wearing braids forever because our hair is most protected and healthy when it is up in some

sort of style. It allows us time to do what we have to do on a day-to-day basis without having to worry about doing our hair every single day. We usually do a style that we keep for a duration of time. Usually two weeks—it depends on what the style is. But I learned from my family. And my father's a historian, so I grew up with a lot of literature and imagery from various African countries and different cultures and ethnic groups and the ceremonial things they do with hair and with masks. I really was inspired by those things, but I was also inspired by some of the regular pop culture stuff that I experienced in the 1990s, and just life. I'm inspired by a lot of artifacts.

One of my pieces is called *Shekere* and it's made to mimic a shekere, the musical instrument. On the other side of it, I have a piece called *Fingerwave Saint,* which is made to mimic a fingerwave hairstyle that was very prominent in the 1990s and that I always had a lot of reverence for because I knew how much time it took to craft black hair into that style. First you have to chemically relax it, then you have to mold it with all of these gels and mousses, then you have to let them sit under the dryer, then sometimes people take a curling iron and do a little bit of extra. So I saw them more as sculptures, and the people who wore them as wearing walking art. But those things were always seen as ghetto. They weren't really respected. I wanted to take that style and elevate it to the highest form as a deity. So I presented that style and created a halo around the model who's wearing it. That's *Fingerwave Saint.*

If you're a creative person, I think you can draw from everything that you're experiencing in your life to create with. Everything has value.

Shani Crowe, *Shekere*, from *Braids* series, 2016.

Your most recent work is *The Rest in Power, Rest in Peace*. It's a room that, you said in an interview, you created to be a space of reflection on gun violence in Chicago. Can you tell us about that room and how it works?

That room was created to appear to be a throne. It's a very basic, blocky, enormous chair in its purest form. A lot of times when people die, you see "Rest in power, rest in peace" on your timeline. But often the people who are survivors of this death, they need a moment to

Shani Crowe, *Rest in Power,
Rest in Peace*, 2018.
Presented as part of
traveling interactive
exhibition *29 Rooms*.

rest and really grieve. A lot of times people don't have time
for that. I wanted to create a space people would enter
with the intention of coming to have a moment of reflection.
On the exterior is a giant throne that you can sit on for a
moment of power; you can also sit and have a moment of
reflection there. And the interior is a candle shrine covered
with reflective gold contact paper, which really enhances
the glow and is literally reflective for your time of reflection.
People were invited to leave a message to someone they may
have lost. But I also opened it up. I mean, really, it's whatever
you want it to be. I think that the experience is up to the
people who come, the patrons basically. I was jokingly say-
ing, like, "If you want a new pair of Jordans, you can write
that down and put that in there too." But most people, when
I looked through the messages that were left, really wrote
heartfelt, thoughtful things. So now I'm trying to figure out
what to do with the messages that were left.

**Of course, this work about gun violence leads us
to Eddie, to your practice. Gun violence is very
much at the top of the political agenda in the United
States. I was wondering what you see missing from
the conversation?**

Eddie Bocanegra I think that gun violence, or violence
itself, is a complex issue. Shani kind of hit on it right about

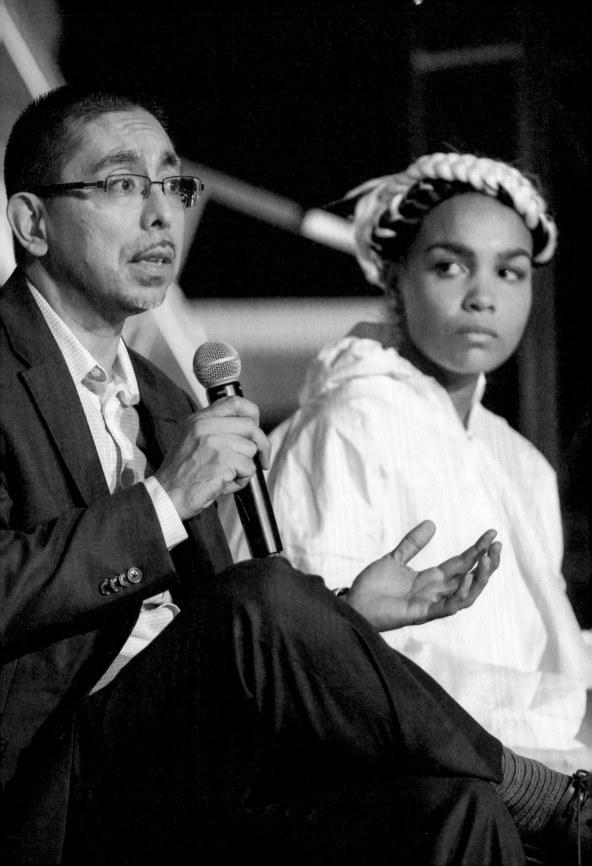

the misunderstandings of various cultures. Earlier on, one of the questions that was asked was about Chicago and what's needed. The truth is that Chicago in itself is a very complex community, and you have to take into account the segregation that has existed in our city for quite some time, issues around race, around class, issues around economic development or lack of. In my experience as someone who was gang-involved at a very young age, as someone who's been involved in the justice system—I did fourteen-plus years in prison—coupled with my education and my work experience, what I see being needed in our city right now are opportunities for employment, particularly for those who are often in the margins. I think about how do we leverage art, for example. Shani pointed out using art as a form of identity, as a form of also healing, so to speak. And I think that for those who are involved in the arts, there are so many creative ways that we can use that and leverage that. I think about the cameras. I don't think there's a bigger weapon or more dangerous weapon than a camera. But how do we use it to inspire others? How do we do it to bring out the best in human beings? How do we use it in a way to create social justice—to outline the complexities of these problems, the root causes of these issues, and afterward think about creative ways to solve these issues?

Shani described her wonderful installation *Rest in Power, Rest in Peace*, which very creatively addresses this theme of gun violence. What role does creativity play in your whole agency to stop violence? What are the challenges that might require you to develop new ideas and also work against common wisdom in some way?

Truthfully, I think that we separate ourselves from this issue of violence. I'll give you an example. There are approximately three hundred licensed clinical social workers working in the Gold Coast, compared with fewer than seventy on the West Side of Chicago, in Austin and North Lawndale. When I hear these stats, I wonder to myself, "Wow. Are the people in the Gold Coast more jacked up than the people on the West Side?" And the truth is no. It's about access. It's about opportunity.

In terms of the world of violence prevention, I think about proximity. Bryan Stevenson says it best, that in order to

READI Chicago
in action.

be able to relate to this issue, you need to be in close proximity to those who are impacted by it. That's important. As embarrassing as it is, as shameful as it is, I share with you that I spent over fourteen years in prison, and let me tell you that it wasn't for purse snatching. And yet I've been able to use my story in a creative way to demonstrate the stereotypes that people might have, the misconceptions that folks might have of people with records. I'm an ex-offender, I'm a returning citizen. Media portrays individuals like that as monsters.

I mentioned earlier on that I was a gang member. But what does a gang member really look like to you? You see me in my coat right now and a suit, but underneath this what you don't see is that my body is full of tattoos, full of scars. And what you also don't see are the invisible wounds that I carry, both psychologically and emotionally. And the last thing I'll say is that the folks that are impacted by these issues are often not only victims but also perpetrators of violence. So it's not until we are able to connect, whether through music or through art, that we'll be able to understand the complexity of these issues, and humanize the individuals that come from these neighborhoods and really, at the end of the day, give them the dignity they deserve.

I wanted to ask you both about your unrealized projects, about something which has not happened yet, a dream, a project that has been too big to be realized.

Eddie Bocanegra I'll keep it brief. I left the YMCA of Metropolitan Chicago just over a year ago. My program there was featured at the White House and in other areas nationally. It was a program focusing just on youth work. For the most part, people are more compelled by working with young people, more understanding, more forgiving. Resources were scarce, but because we had a spike in violence in 2016, with over 750 homicides and close to four thousand shootings, the foundations in the city of Chicago came together. Long story short, I got tapped in. Heartland Alliance is one of the oldest nonprofits in the state of Illinois, and the CEO, Evelyn Diaz, approached me and said, "Eddie, we have this project. We think you're the best person to run this."

This project is focusing on the less than one percent of folks in particular communities who are known to drive the violence based on police data, hospital data, and community information. We're targeting those people. They're not coming to us, we're going to them. And we're providing employment opportunities on the spot. But equally important, we're doing cognitive behavioral therapy. When they told me how many resources were behind it and the organization that was behind it, I said to myself, this is a dream come true. I'm currently doing a project that so many other people thought was not going to succeed.

People ask me, "Eddie, you've been to the UN, you've spoken there. You've traveled all over the world. How did you get where you're at?" And the truth is that I had support. I had people who guided me, and I had people who provided me access. And I also had therapists who were able to bring out some of those challenges that I faced. Even now, ten years after being out of prison, I still struggle with some things. So this project, called READI Chicago, an initiative of Heartland Alliance, is perhaps one of the most expensive but best supported projects in the city of Chicago, and is addressing gun violence on the very front end. And that means that part of the work I'm doing is to really change the narrative of the folks I'm working with.

Thank you very much, and Shani, your unrealized project?

> **Shani Crowe** Wow. I have so many things I want to do, and my gears are always turning. But one thing that I would like to do is embark on a research-based project using EEG machines to

Post-it Note,
Shani Crowe.

study the actual impact that braiding and personal care have on people, measuring people's cortisol levels, things like that. The reason I want to study this is because I've had clients since I was like eleven or twelve years old. More of my life has been spent braiding people's hair than not. And some of my clients will come to me just to talk. They don't care what I do to their hair. Some people really feel a deep relaxation when I'm doing their hair, and a break from the stress that they feel. I want to be able to measure that, because if that is a real therapeutic process then that's something that needs to be scientifically evaluated and then made available to more people on that basis, not just on a beauty basis.

In addition to that, I would like to travel to different countries in Africa and actually across the diaspora—Colombia has a really intense and unique hair-braiding culture among the Africans who live there, or African descendants. And I would like to be able to continue that research while also studying their craft and doing a cultural exchange piece. I want to get scientific with the braids.

Thank you so much. A big round of applause for Shani and Eddie. Thank you very much.

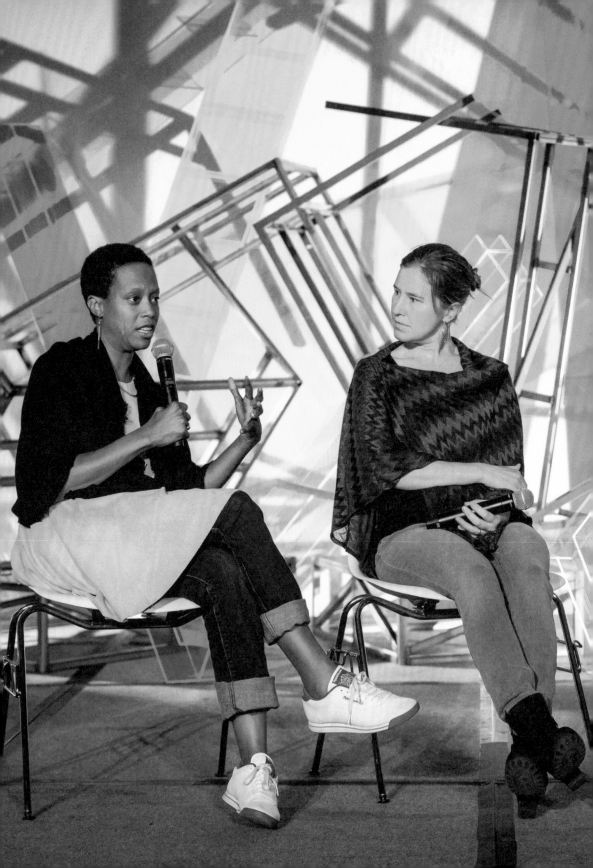

Hans Ulrich Obrist

It's now my immense pleasure to introduce our next two speakers, Eula Biss and Amanda Williams. Eula is an author, most recently of *On Immunity: An Inoculation*, one of the *New York Times Book Review*'s 10 Best Books of 2014. Amanda Williams is a visual artist and trained architect. Amanda was one of the artists included in the American Pavilion at the 2018 Venice Architecture Biennale.

A very, very warm welcome to Eula and Amanda. I thought we could begin with the American Pavilion at the Venice Biennale. I was there and saw your great work, Amanda, which was a collaboration with Shani, so it connects perfectly to the previous panel. Can you tell us about that piece?

Amanda Williams and Eula Biss.

Amanda Williams You saw some images in Shani's segment. The piece is called *Thrival Geographies (In My Mind I See a Line)*. It's actually a collaboration between Andres L. Hernandez and me. And we brought Shani Crowe in as our third collaborator. For those of you who don't know, the Venice Biennale alternates between art and architecture. And for each session there's a commission that determines what the theme is going to be. So this year it's the Architecture Biennale, co-commissioned by the School of the Art Institute of Chicago and the University of Chicago. And the theme is "Dimensions of Citizenship."

Andres and I were invited to be a part of a project that looks at different scales of citizenship. We were the initial scale, which is the scale of the individual. And we opted early on to challenge the premise that was given to us, which is that every American enjoys the

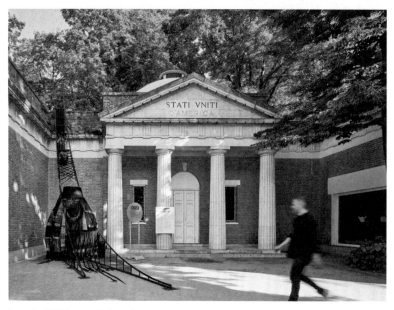

Amanda Williams + Andres L.
Hernandez, in collaboration
with Shani Crowe, *Thrival
Geographies (In My Mind I See
a Line)* at the US Pavilion,
Venice, 2018.

rights of citizenship. Right now, issues of immigration
make obvious that citizenship cannot be taken for granted.
As African Americans have long experienced, not everyone
is able to actualize the rights, benefits, and responsibilities
of citizenship. We chose to think historically, about how
freedom and the pursuit of freedom was the basic beginning
of citizenship for enslaved Africans. We looked at Harriet
Tubman and Harriet Jacobs, two women who had different
strategies for achieving their freedom and helping others
achieve their freedom.

Andres and I studied architecture at Cornell together,
and we really wanted to think about the way that their
pursuits of freedom played out spatially. So we talked about
spatial practices. The term *Thrival Geographies* comes from
an idea of expanding beyond survival into a mode called
thrival. And then, in particular, we wanted to imagine what
it means to be placed in the context of *this* Venice Bienniale,
and the American Pavilion, which is modeled after Thomas
Jefferson's Monticello. Its style is neoclassic architecture,
but for most brown people it's a plantation and about slavery.
So why would the US keep that as their icon, representing
American democracy to the rest of the world? Our piece was
an opportunity to counter that. It was placed in the courtyard

and it really stands in for blacks in public space, and in particular black women in public space. We wanted to foreground not only ideas about survival and then going beyond to thrival, but to bring Shani in to talk about overlooked black spatial practices and also material practices that are unusual to the discipline of architecture. You've seen her amazing braiding skills and her amazing conceptual skills but also this expertise in hair as one of the strongest material fibers. We wanted to bring it back to a conversation about architecture so that it couldn't be dismissed as this other thing, so nobody could say, "This is the real architecture, and that's some other thing." It was an opportunity to show that the homogeneity of a profession actually misses out on its opportunity to thrive. By including these understandings that we have and bringing it to this larger audience, it really was a moment of contrast with the status quo and what is typically seen at these kinds of venues.

I wanted to also ask you about your most famous project, which is called *Color(ed) Theory*. The project gives new life in a way to condemned houses, to vacated houses, to abandoned houses in the Englewood neighborhood. I've always been very fascinated by this project, because I'm friends with Edi Rama, who is an interesting example of a social sculptor because he is a painter and a politician, and he is now the prime minister of Albania. And it all began by him coloring buildings. But as I found out, your process is very different than his, because you actually worked with the families and community members. It ties in with what Dawoud Bey was talking about before. It's kind of like a conversation. Can you tell us about the epiphany of *Color(ed) Theory* and how you worked with the community on this project?

Sure. So as I mentioned, I was trained as an architect. Color theory was part of our educational experience and has its roots with Mies and Bauhaus training. The idea that you can use color as a medium to inform or imply space is not a revelation to anybody in the creative field. But the idea here is that somebody like me has something to offer to

Amanda Williams,
Flamin Red Hots,
from *Color(ed) Theory*
Suite, 2014–16.

that conversation because I've come from environments in which color also informed my sense of beauty and composition, not from the standpoint of modernism or cubism but from the South Side of Chicago. I jokingly said that I was an expert in *colored* theory, and then started to develop this palette of colors that had to do with coded language, things that are signifiers on the South Side: pink oil moisturizer, Ultrasheen, Crown Royal, currency exchange. These are colors of a particular moment and a particular geography within the Chicago landscape. If you ask a black teenager about signifiers for right now, they'd say Twitter or Ventra or other colors. I wanted to use those colors to decontextualize or to pause to understand the way in which our landscape has been shaped and how much cultural components influence the way we understand how our communities come together.

And actually it wasn't something I got permission from the community to do. It wasn't something I used to kind of connect with the community. I am the community. I'm from these neighborhoods, but I also am coming from the outside. I think for me it was important not to get permission, and instead just do the act and then see what the result was. And the reactions are as varied as the colors. There are a number of relationships that have been formed but there are a number of community members who don't

like the project or are offended or have issues with it. But I think it was important to do the action. I think that's what's really drawing people. While it's intriguing, it's really the act of not waiting for permission, which is so much of what my architectural training was about in terms of how I'm expected to think about changing these landscapes.

There have been moments in Chicago of very intentional city planning. The Burnham Plan, for one, where there is the idea of injecting parks as an antidote. Neighborhoods are also important and play a role in both of your works. How would you, both of you, talk about Chicago neighborhoods in 2018 as a construct in your work? Maybe Amanda first, and then it's the fluid transition to Eula.

I did a crash course, reading of all of Eula's writing. I was curious why Alison had put us together.

In your writing, you talk a lot about when you moved to teach at Northwestern. You were living in Rogers Park, a neighborhood that's probably the furthest north neighborhood in the city. And then there's me dealing a lot with Englewood and Auburn Gresham, which aren't the furthest south, but in relation to Rogers Park, they're definitely polarities. But there are also so many similarities in terms of what the landscape might look like, even though they ended up that way for different reasons. For me, there's a kind of absurdity in how we silo ourselves and see that as a pride thing. It's like, we have seventy-seven community areas!

But in your writing, Eula, you bring up data and statistics about the disparities, about how many of those neighborhoods are not integrated. I think you said something like all but twelve neighborhoods are 99 percent white or black or Latinx. Chicagoans know that, but how do we really use an understanding of that to change it? For me, it's been interesting to try to use visual language to bring that to the fore. That's what I've really been trying to get at with the recent work. The writing of yours that I was reading is really interesting and helpful to think about. I've been so fixated on the South Side. It's been useful to see ways that the North Side and West Side have synergies with that as well.

Eula, what would be your take on that?

Eula Biss I've always been an outsider in some way in the communities that I've written about. That's partly because I spent my twenties moving. I moved ten times in ten years. Every time I arrived in a community, I was learning all over again, hearing things I hadn't heard before and learning ways of being in a space that I hadn't known before. That part of my life has ended now, now that I've been here for fifteen years. But still when I was living in Rogers Park and writing about Rogers Park, the place felt very new and very raw to me. I think the individual word is to me what color is to you, Amanda. It is basic to my art, the way color is basic to your art.

Part of where the title essay of my book *Notes from No Man's Land* came from was a single word that I heard in Rogers Park: pioneer. And I kept hearing this word. It was most often spoken by white people in the neighborhood, and it was just full of vibration and terrible history for me. I think I heard it five or six times before I felt like, okay, I have to work with this word. That longish essay came out of that single word, and quite a bit of research came out of me trying to figure out what people in this space really mean when they're using that word. What is a pioneer now? What was a pioneer in the age that I associate with that word?

Each new community space I enter usually brings up a language that is new to me. I live now in Evanston, which is just north of Chicago, and it's a new community for me. I'm still learning what the language is there. But again, there are words and habits and practices that feel new to me. So I still feel like an outsider or a spy.

Eula Biss, *Notes from No Man's Land: American Essays* (Minneapolis: Graywolf Press, 2009; reissued 2018).

We've talked about what is missing a lot in this marathon. We started with Eve right at the beginning, talking about schools. Now something that is also going missing in many cities is libraries. Mexican artist Pedro Reyes has a global project to save libraries from extinction, which I think is one of the most interesting social sculptures right now. Libraries play a very big role in your

universe, in your thinking. And former Chicago
mayor Richard M. Daley said, "Our vision is to have
the finest library system in the country and the
world. Libraries are essential to the picture
of our city. Libraries are the spirit of Chicago."
I read several interviews where you said you love
libraries, so I wanted to ask you to reflect on
Richard Daley's quote and what libraries mean to
you as a Chicagoland resident. How can we save
libraries and make sure that libraries remain part
of the spirit of Chicago?

One of the most moving speeches I've ever heard was
when the novelist Nami Mun accepted an award from
the Chicago Public Library Foundation. This was a few
years ago, and she talked about what libraries had been
in her life. She was homeless for a period of time, and
during that time, libraries were where she went to get
herself together so that she could go to a job interview or
something like that. Libraries were where she used a com-
puter. Libraries were the launch pad for her to become
the writer that she is today, but in ways that didn't always
have to do with books. It was also using the physical
space. I feel very aware of that in my everyday life. I write
in the quiet study room on the third floor of the Evanston
Public Library, and I write among people who are there
for lots of different reasons. There's always somebody
in there who is sleeping, and there are people who have
come there just to be alone. There are people doing
schoolwork and there are people who, like me, are doing
their professional work. So I think, beyond the books,
which is the obvious purpose, there are all these auxiliary
purposes and roles that libraries serve. They've been an
incredibly important work space for me, because for
most of my career I haven't been able to afford an office.
I wrote one book mostly in the library in Iowa City, and
another book mostly in the Evanston Public Library.

Amanda told us about her most recent work,
which is in Venice. I wanted to ask you what you're
working on at the moment.
 I found this great quote where you said, "In
On Becoming a Novelist, John Gardner suggests

that writers are like runners and that some of us are sprinters and some are marathoners." And that, of course, fits today's event. To continue your quote: "I don't know if that's true, but I have thought of myself, for most of my career, as a short form writer. With some stretching, I can train myself into a longer form, as I did with *On Immunity*, but that is much harder for me than short form writing." I wanted to ask you, in this marathon, to tell us if you continue with short stories or if you're working in more marathon-related formats.

Eula Biss The work I'm doing now is very much like this marathon in that it's very short pieces. Each one is no longer than two pages, and each has a title. In some ways they're the shortest essays I've written, but none of them stands alone, really. The effect of the book is cumulative, so I need all of them to be together. I was noticing, as I was sitting here listening to these interviews, the way that it seems the power behind this marathon is the refrains, the returns, the ideas that come back again. The way there are unexpected connections between people who you wouldn't think would be talking to each other. And that's more or less the form that I'm working in now. I said that I had to stretch to write a book-length work, and really I think I cheated in that stretching, insofar as the last book is made up of thirty chapters that are each quite short. It's really a long work that's a lot of short works. The book that I'm working on now is a long work of even shorter works.

Eula Biss, *On Immunity: An Inoculation* (Minneapolis: Graywolf Press, 2015).

I know we're out of time, but I do have these very last, very urgent questions prompted by you mentioning that we have these returning questions. The eternal return of the question What does Chicago need? is my last question to both of you. What is urgent? You've already addressed it, both of you, but I think it would be great as a conclusion for you both to tell us what you think is most urgent.

Amanda Williams I think what Chicago needs is for everybody to operate outside of their own best self-interest. If we all just tried a little harder. We're not missing anything, but there's at least half of this city—and I won't say

Post-it Note,
Amanda Williams.

which half—that's not trying hard enough, that assumes it's okay. I can't imagine having one arm that didn't work and one arm that did, when I could do something about it. That's what I think it needs. It needs everybody to try a little harder.

Eula Biss I'll just second that. Let's try harder. I love it.

That could not be a better conclusion. I want to just end with something Amanda said, which I think fits this perfectly. You said the arts matter because they continue to be the most effective way to inspire societal change, or change of society through imaginative possibility. Eula and Amanda, thank you very, very much.

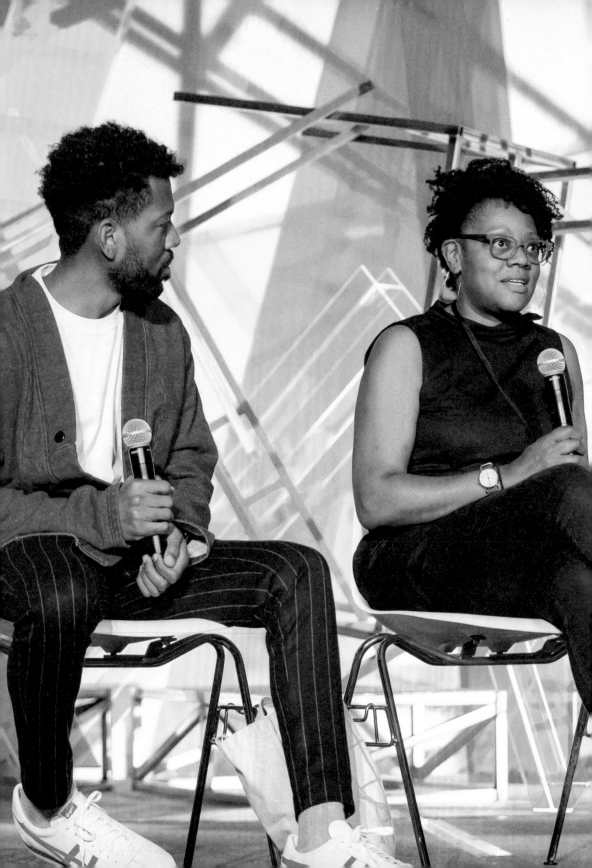

Hans Ulrich Obrist

It's now my immense pleasure to invite on stage our last guests of the interview marathon. A very, very warm welcome to **Cauleen Smith** and **Brandon Breaux**. Now, of course, Cauleen, we've already seen your film, so maybe we should begin with that and then go into Brandon's work. I wanted to ask you to tell us a little bit about the film we saw earlier, which was a world premiere, so thank you.

Brandon Breaux and
Cauleen Smith.

Cauleen Smith It was so great to show it here in this space, to this audience.

Basically, it was just a really informal document of an event that was curated by a wonderful artist, Sabina Ott, who has transitioned and is no longer with us. She ran a space in her home called Terrain. She curated artists to do site-specific works in her home on her front lawn, and she invited me to do a procession for the July 4 parade with these banners. I actually didn't want to do it! I was really reluctant. I live on the South Side. I didn't know anything about the neighborhood of Oak Park, and I didn't think it would be a relevant context for the banners. Sabina was insistent. We did it. It was a beautiful convergence of her friends and students and neighbors and people who were friends of mine that I didn't know lived in Oak Park, and a middle school in the neighborhood named after Gwendolyn Brooks. So when we turned a corner, the teachers and students were howling. It ended up being a beautiful event. I'm really grateful for it. And the film was shot by a former student of mine.

You of course started as a filmmaker in 1998 with the legendary *Drylongso*, a film that premiered at

Sundance. What brought you to film, and what were your influences? Because you have all these mentors, like Angela Davis and Lynn Hershman Leeson.

Yeah, for two years I studied with Trinh T. Minh-ha, a really great filmmaker. Lynn Hershman Leeson is definitely really formative, and made an imprint on me. But in terms of popular movies, I went through the classic film-student phase of French New Wave and Tarkovsky like everybody else. I found my way back to experimenting after spending a lot of time in the film industry and dealing with narrative and screenplays, and feeling like I was tired of asking for permission to do stuff.

Cauleen Smith,
Drylongso (still),
1998. 16mm, color,
sound, 82 minutes.

And, of course, you also have this big connection to archives. I mentioned that earlier when I introduced your film. You very often visit archives, and there is this incredible connection to Chicago. You spent time here in the city, and we earlier spoke about multiple archives and Joseph Grigely spoke about the importance of archives. For you, the Sun Ra archive is very important. Can you tell us what connects you to this archive, why it's important, and how you use it in a non-nostalgic way to kind of produce the future?

Cauleen Smith, *Black Utopia LP*, 2012. Limited-edition double vinyl LP with 32-page booklet insert.

Yeah, I was invited to do a residency in Chicago about Chicago, and you have to propose an idea for these kinds of residencies, and I stumbled on the Sun Ra archive. I didn't realize that his becoming happened here in Chicago, and when I realized that I was, like, "Oh, I have to be in the city and I have to learn how to become." For me, the archive is where I go to learn. People are always looking to discover in archives, but I'm actually just looking for the most mundane models for practice. Like, what is the everyday life of an artist that I admire and the ephemeral accumulation of that work? The Sun Ra archive—both his papers at the University of Chicago, which is everything from canceled checks to screen-printed LPs, and the sound archive, which is up on the North Side at Experimental Sound Studio— offered lessons about how to make and how to become the sort of artist you want to be.

The work that you're doing for the Serpentine with Kamasi Washington connects to music. Can you tell us a little bit more about how you connect your visual art practice and the world of sound?

There's so much to say about music and visual practice. What I'm thinking about right now, Hans, is the way in which so many musicians actually have a visual practice

or a writing practice that isn't considered. When I got to meet Kamasi at the Serpentine and we sat down and talked about the way he's thinking both visually and in a literary way, I realized there was almost no gap between our various practices. I think that we're constantly learning from each other. There's this constant exchange and transformation of sound into film, another kind of time-based media, or sound into image, or sound into object and vice versa. It's constantly feeding me. The music itself kind of challenges the form.

You said in an interview that you favor dissonant sound design. You get excited when the sound you hear disagrees with the image. I thought that was fascinating, and I was thinking about that in relation to your films. Can you tell us about that, that disagreement?

It's like a disruption because movies are so seductive. You can do everything in your power to lure someone into your image, and all you have to do to create estrangement with the viewer, an estrangement that creates an attentiveness—all you have to do is change the sound a little bit. And suddenly they feel that something isn't right, maybe without even understanding that it's the sound. I enjoy producing those tensions. It's like acupuncture, flicking the needle, creating a kind of attentiveness.

And your collaboration with Kamasi leads us to Brandon Breaux's practice. Because Brandon, you also work very closely as a visual artist with the world of sound, and for many, your story begins with the creation of Chance the Rapper's iconic *10 Day* album. We want to hear today also about other things, because of course your practice cannot be reduced to that. It's one of the many things you do, but I still wanted to begin with that. I wanted to ask how you and Chance the Rapper collaborate and how it relates to what Cauleen was describing.

Brandon Breaux, cover for Chance the Rapper's *10 Day* mixtape, 2012.

Brandon Breaux Well, with our early collaboration, in many instances I hadn't even heard the music yet. But because of my design background, the most important

thing was figuring out what to leave people with and getting the idea up front, getting the energy. It was my visible interpretation of sound sometimes. But mostly just the concept, creating something that would lead people into this body of work. What would they see before they heard anything? In many cases, I hadn't even heard anything yet. I was just creating.

As time has gone on, we've changed a whole lot. Now, he'll send music and then I'll send back a visual to the music, and usually it's not anything he imagined. I think interpreting sound is really interesting, because you can't gauge what somebody might be seeing when they hear a sound. If you listen to music and you said draw the first thing that comes to your mind, you'll get a variety of different imagery. So it's really interesting to me to work with somebody in a different medium. I can't imagine what sounds he's going to push my way, and he can't imagine the visuals that come out of it. When we start that dialogue, that's when projects usually come together. It's the same when I collaborate with other artists as well.

Brandon, who are the designers who inspired you? I'm close friends with Peter Saville, the legendary designer whose work has a complete connection to music—he developed all the graphic design for Joy

Division and later New Order and then, of course, designs many other things beyond music. In a similar way, I have a feeling that music is one aspect of your design. I was wondering if Peter Saville is an influence. Who are your inspirations?

Brandon Breaux,
Self-Portrait Neon for
Bud Light, 2017.

My inspirations are contemporary artists like Murakami, but also artists I first encountered when I was younger. I began to see how they studied forms, like Leonardo da Vinci. I know it's probably corny to say, but he was the first artist that I, like, physically had printouts of pieces of his work, and I noticed immediately his attention to detail. And Michelangelo. I was interested in the Ninja Turtles too, and the Ninja Turtles were named after the artists, so that was all I needed. But that is why I fell in love with portraiture, why I fell in love with figure drawing, from those moments, and then other design movements. I really got into it when I was in school, and I developed a love for design and typography, and all those things kind of come together now when I'm looking at a blank page.

Since working with Chance, you've also collaborated with big brands, companies like Bud Light. I was wondering how you balance the artistic expression with the commercial work. How do these two things fit together?

Yeah, it's kind of crazy for a lot of people. My work with Chance opened me up to a lot of commercial opportunities. I'm a fine artist at the core, and that's how I like expressing myself mostly. The idea of the commercialization of your art is kind of looked down upon. For me, it was really finding ways in those relationships to talk about something that was real and authentic, that impacted my community and where I came from. So if I can't make sense of it, within my personal story and my personal experiences, I don't do the work. If there's no aspect of the project that allows me to express that, I stay away from the work. But for the Bud Light project, we did an art show where I spoke about Chicago from my vantage point and from the community on the South Side I was raised in. So that's how I find a way to balance them all, and it helps me sleep at night.

Eula was talking about the importance of these recurrent questions in the format of the marathon. It's the eternal return of a couple of questions, and one is, of course, the unrealized project. The reason I keep coming back to that question is because I think it's really interesting that we think about what artists would want to do, what they can't do within the current framework of existing institutions, and how if we change it a little bit these projects can happen. It's pragmatic. We're not talking about these unrealized projects in order to keep them unrealized. We keep talking about them to make them happen. So I wanted to ask you both to tell us about your unrealized projects, something you'd like to do.

Brandon Breaux I love this question. My unrealized project: I want to transform my grandfather's home into a museum. And the reason I want to do that is because the house is run down a little bit. It's kind of going the way it's going. I think that we displace value a lot of times. But so much of our life experiences and so much of our family history has come through that space. So for me to reinterpret or represent that space and those ideas in that home and view it in that capacity is really important to me. That's one of the projects I really want to do.

Cauleen Smith I've been dying to answer this question. It's ironic. I was thinking about when I moved from LA to Chicago, I came here looking for models for a certain kind of way to inhabit buildings. So I went to Experimental Station on the South Side. It's an art space, and it has artist studios, it's got a bike shop, it's got a cafe. I was living in LA, where the strip mall is a thing, right? And to me they've always been incredibly exciting. You go to a strip mall and you might get the best sushi you have ever had in this little podunky, ugly structure. I've always fantasized about taking over an entire strip mall, an entire parking lot, an entire block, and appropriating the form of the strip mall and these shops and turning them into experiments in exchange, where money becomes less of an issue, but trade, exchange, is the thing. So there are things masquerading as shops that are actually experiments or art projects.

We talked about libraries before with Eula, and I know that you also have book projects that you want to make happen.

Oh, so many.

Can you tell us about your books?

The book project that we're gonna do?

Yeah, our book project.

Yes, *Manifesto*. So, I just keep writing them. Every time I get mad about something, I write a manifesto.

That's so fascinating, because today we've had lots of different generations of artists who were part of groups. I kept asking if these groups have manifestos. And you want to do a book of manifestos!

To me, they're provocations more than anything. They're about experiments. They're proposals for a way to do something.

What's the most recent one you've written?

The Bicycle Manifesto. It's just black people on bikes. It's amazing, because they're everywhere and yet invisible. When you look at bicycle magazines, we're not on the covers, we're not in the magazines. And yet in any city, there are black people riding bikes everywhere, with a particular kind of style and a particular kind of purpose. I started gathering photographs of them, and then when I started riding a bike I realized there's a real relationship between a body powering itself going down the street and the way you interact with your community, and that the violence of the power of a car is an alienating device. It's the last thing we need in our neighborhoods. Though the car is a symbol of a kind of maturity for your average, working black person, the manifesto is about asking people to consider the toy, the bicycle, as an actual device of liberation.

Fascinating. The late Gustav Metzger, who passed away last year, had this piece called *Kill the Cars. The Bicycle Manifesto* kind of leads us back to the city and the future of the city, and that's another recurring question I've asked everyone today. So, last but not least, what does Chicago need? What is urgent? Brendan lives in Chicago, and Cauleen used to live in Chicago and is now back in LA but knows Chicago from many years here. So I want to know from both of you, what is urgent for Chicago?

Toni Preckwinkle for mayor. Please and thank you. I would move back here to vote for her. That's all I'm saying.

Brandon Breaux Agree. I think it's happening, and I almost don't want to speak on it.

I also feel like empathy. And I think that's available through art, expression. I'm an advocate for the arts and artists. I think that's what's really important. I think that's what we're missing. Seeing these stories from different vantage points, and seeing them in unique places and in ways we can't imagine, ways we haven't seen or haven't imagined yet. That's what I think Chicago needs.

Thank you so, so much. Cauleen Smith, Brandon Breaux, thank you so much.

Post-it Note,
Cauleen Smith.

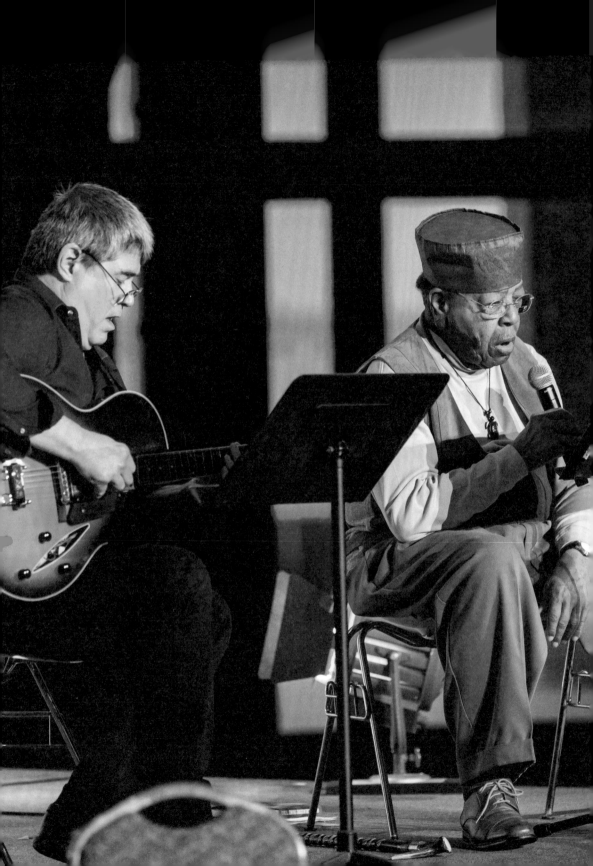

Ricky Murray

Hans Ulrich Obrist **We have a last performance. It's now my immense pleasure to introduce Ricky Murray, a vocalist who sang with Sun Ra from 1956 to 1962, performing such incredible songs as "I Struck a Match on the Moon." He currently performs with the Mudcats, who specialize in New Orleans jazz and blues. It couldn't be a more wonderful transition from Cauleen telling us about her inspiration from the Sun Ra archive to the amazing, legendary Ricky Murray. A very, very warm welcome. Thank you very much. Thank you for being here.**

Ricky Murray accompanied by Tim Burns.

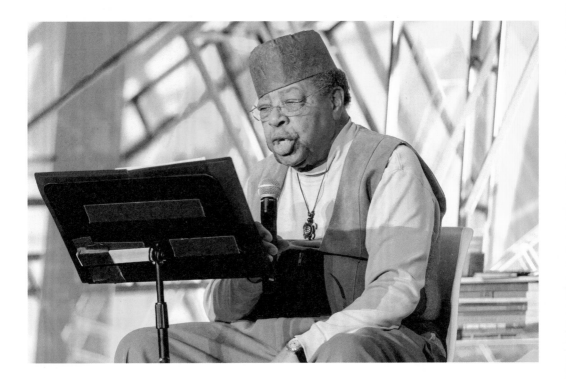

Dominick Di Meo, *Untitled (Moon Watch)*, 1972. Acrylic and synthetic polymer on canvas, 28 × 22 in.

Dominick Di Meo and Hans Ulrich Obrist in the artist's studio, New York, 2017.

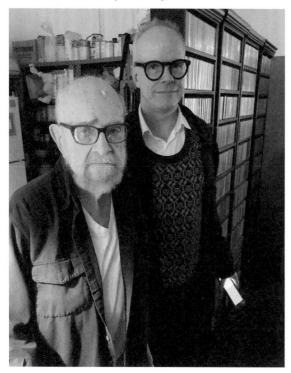

Hans Ulrich Obrist

My friends Nancy Spero and Leon Golub told me about Monster Roster and Chicago when I met them in the early 1990s, and it's through them that I discovered the work of Dominick Di Meo. When we started working on an interview marathon for Chicago, my first idea was to interview Di Meo on his pioneering work and the Monster Roster movement.

As Di Meo could not travel to attend the marathon, I interviewed him in New York on October 28, 2017. The interview was published in *Newcity* magazine on September 26, 2018. I am grateful to Jasmin Tsou from JTT and John Corbett and Jim Dempsey, who made this interview possible.

Hans Ulrich Obrist **How did you initially come to art? Was there an epiphany? What brought you to art?**

Dominick Di Meo Well, I guess in part it was that I was limited physically. Because I have a crippled arm and leg, I couldn't indulge in sports like other people. I don't know if this is apocryphal or not, but I went into the Crippled Children's Guild with polio. We were bound in plaster casts. I'm lying down, and there's a Christmas party, and they gave out free toys, right? And I was given a set of Tinkertoys. But I was having a lot of trouble, because this arm was in a cast and I couldn't put things together. One of the nurses or aides saw that and she immediately picked it all up and took it away. And that broke my heart. It was a challenge that I was working at, and by her taking it away, it did something to me.

So something happened there.

Right. And later, in school, you know, one of the few things I could do was art classes, so I was encouraged by the art teachers. I wasn't good academically, you know. And curiously enough, one of my fixations as a student was to do heads [*chuckling*]. And then to come to Chicago, my ambition was to become a landscape painter—a naive idea [to be a] landscape painter. But in Chicago there was a big movement ... those brothers who did the famous paintings of corroded flesh and all ... Ivan Albright and his brother Malvin. They were a big influence, especially Ivan, being an internationally known artist in Chicago.

Ivan Albright was an influence?

I think on everyone in Chicago, because he was a big star, and was still alive, and had a studio. This was like in the mid-forties. And I think that's what was behind the Monster School, in part. And then while we were in school, the Arts Club of Chicago put on a big [Jean] Dubuffet show. We were all really impressed with that stuff, and the Art Institute acquired one of the big heads; a curator named Katharine Kuh acquired that for the Art Institute. That was a big, powerful thing.

You are one of the protagonists of the Monster Roster. How was that name found, and how did it begin?

Dominick Di Meo, *Untitled (Blue and Orange with Black Figures)*, 1965. Acrylic and synthetic polymer on canvas, 74 × 60 in.

Well, Chicago culturally was kind of a dead city. You know, it wasn't a very exciting city. It had one really good gallery at one time under Katharine Kuh, who then became a curator at the Art Institute—before or after, I don't remember which now. So it was kind of dead creatively, except for the Albrights and a few others.

So Leon Golub and some of the older artists formed an organization called Exhibition Momentum, and we put on big shows, mainly by the more mature men who had just returned from the Second World War. And that created a lot of excitement. And within that organization was kind of a nucleus that were doing similar work, like Fred Berger, Leon, George Cohen, Cosmo Campoli, as far as I know— that was a tight group, really—and Franz Schulz at some

point. [Schulz] was a critic, he had been an artist, and he knew everyone. He's the one who coined the term Monster Roster, in one of his articles.

So he found it, he coined it.

Yeah, he coined it. But it was a loose thing, like, I supposedly am part of the Monster, [and] you know there was a second generation of people, but the heart of it was those people I just mentioned.

How did he find that name? Why are you Monster Roster?

Well, you have to ask Franz Schulz that, if he's still alive. Mainly because it wasn't aesthetic, it wasn't like the New York abstraction schools. There was a MoMA exhibition by Peter Selz called *New Images of Man*, which a few Chicagoans were in, including Leon Golub and Cosmo Campoli. In the review of that show the critic referred to the "monsters from Chicago." I think Franz saw that and came up with the "Monster Roster" moniker. Franz liked the idea that "monsters" sounded tough and gritty, and that reminded him of Chicago, so there's a lot of stuff going on in there.

And how would you describe Chicago at that time? Because obviously, retrospectively we have the feeling that something happened there, it was a very feverish moment. What are your memories of Chicago?

Well, outside of institutions like the Arts Club and the Art Institute, and the Institute of Design, it was kind of culturally dead, as far as the physical, the visual arts. So the artists formed their own organization to put on shows. And then later I was involved with the younger artists, putting on shows called Phalanx. At the Institute of Design, at Illinois Institute of Technology, they had a big show in the lobby in one of the Mies van der Rohe buildings. But the reason the artists had to form these shows was that it was culturally dead there. We brought in people to judge the show. Yves Klein was one. We brought in curators from

the Whitney, famous people from New York who juried the shows, but then through Phalanx we didn't have juried shows. The artists, the younger artists and I, chose the artists from Chicago. We picked the show and put everyone that we thought was important in the Chicago scene into those shows.

How do you connect to the historic avant-garde? Because looking at your early work, there are collages, which one can somehow link maybe to Dada, or Hannah Höch.

Those were important factors, you know, because it was on everybody's lips, who were pretending to be creative, visual artists. Like I used to look at Paul Klee a lot, you know. I was heavily into all that. And they were big influences on me, and I would assume on the others, a lot of the others.

But what glued you together? What did you have in common? There was no manifesto; you didn't have a manifesto.

Dominick Di Meo,
Startled Personage,
c. 1968. Acrylic, spray
paint, and transfer
on canvas, 48 × 36 in.

No, no, no. It wasn't a movement where we all together decided this is a movement. It wasn't like—it was looser. If there was any manifesto, it had to be between Leon Golub and George Cohen, because they were intellectuals, they talked about it all the time. But then Don Baum was putting on these shows at the Hyde Park Art Center, again because Chicago was such a deadly art scene, you know. And I remember Jim Nutt was a student and lived in my neighborhood, and he saw me as a serious artist who was spending his whole life making art. So he became a little influenced by me, he wanted to work in my studio, help me out, as an assistant. I didn't like that idea because I liked to be private. But we used to play chess together. And he, he would get angry when he lost, he would throw the chair, and I said, this guy is gonna make it big [*laughs*]. He was so serious, even about chess. He had to be a winner.

That's hilarious . . .

So I had to put that in, it was very funny . . .

Looking at your books, there is a recurrent theme of the sea. There are seasides, there is liquid, there are, you know, humid landscapes.... What's the connection to water, to the liquid?

Well, I can tell you when I was in Italy, I was impressed by the fact that I saw construction of a highway up in the hills, about two kilometers above sea level, and they're excavating the hills to make this road and there were sea-shells way up there, two kilometers above sea level. Stuff like that would make a big impression on me. And then, because my folks were immigrants, you know, their stories about how they came over on the ship. But I don't know why, what the connection with water and the sea was. I can't answer that.

What's the role of drawing in your practice? Because when we did the Hairy Who interviews, a lot of these artists are doodlers. What's the role of drawing in your practice?

Teachers like Kathleen Blackshear would take us to the Field Museum. All the artists: Golub, me, you name it, we all went to the Field Museum. We spent so much time at the Field Museum, drawing, looking at artifacts from the past, you know, Paleolithic, whatever, animals, blah, blah, blah. We were there all the time, it wasn't far from the Art Institute when we were students.

I wanted to ask you that. Because the other day I saw Betye Saar and David Hammons. And they came to Chicago I think in the 1960s or '70s at some point, and the Field Museum was a really impor-tant museum for them. And Leon Golub also always mentioned the Field Museum. Can you tell me a little bit about your memories and what was so important about the Chicago Field Museum?

It's just that it was one of the learning tools, or the experi-ences with past cultures, like Mayan, there'd be, you know, like Aztec. African sculptures were there, and earlier periods, all of this intermixed with artifacts from all these cultures, like so-called primitive and earlier cultures. We

were all turned on by it. It was a big learning experience, it was an exciting thing to go there all the time.

Did music play a role in your work? Dan Graham always says we can only understand an artist if we know what kind of music he or she is listening to.

I was heavily into early jazz. I played trumpet for a while, and I gave it up because I couldn't devote enough time to it. If I was going to do visual art, I had to choose one, so I did the visual art and gave up the trumpet. And partly because of the Field Museum experiences, I was interested in all kinds of ethnic music, like Cajun music, African music of all kinds, you name it. And classical music too.

Do you know Studs Terkel?

I met him a few times. Yeah, I used to listen to his program on the air. Once we were in a record store, and I was looking at some stuff—this was the LP days, the shellac days of the old 78s—and he started talking to me, and he suggested something or other. I'd see him at demonstrations too. Because a lot of us were politically active. Like I was very important in the anti–Vietnam war activity, and was one of the instigators in Chicago where we collected work to send to the Peace Tower in LA—you know, that famous, antiwar thing, partially started by Irving Petlin. It was my studio that collected the work to ship out there. We made banners for demonstrations. And we did silkscreens for antiwar groups, you know, for nothing.

So in a way, some of the Monster Roster artists like Leon Golub, Nancy Spero—you had that political aspect. Politics are a common ground, is that correct?

Right. Leon, yeah, was heavily into stuff that I was too. As were other Chicago artists, you know.

Of course Leon did these napalm paintings. Did these political aspects also enter your painting?

Well, no, I didn't put it in my painting.

So you kept it separate.

Yeah, it might have crept in, you know, because I don't think so much about it. I tended to work when I was prolific, I tend to work instinctively. I didn't think about it too much. That's why all my pieces tend to have the images of some of the other works.

So is it like a stream-of-consciousness? Is it like an automatism?

I figure each piece is a piece of the one work. You know, just one stage of the work I'm trying to express.

So it's almost like biologically evolving.

Yeah, an organic thing that just keeps on going, you know.

And where is it now? What's the last piece you've done, the most recent work? What are you working on right now?

I'm not doing much work now because I have to do everything with this arm. And I've gotten very weak, so I can't even stretch a little canvas. I'm just finishing a very few things now. And I can't even stand up, actually. I can't bend too long because of my back. I've got all of these physical problems. And then I've got macular degeneration—I can't see too well, especially out of this eye. So ...

How old are you now?

I'm ninety. I'll be ninety-one in February [2018. This interview was conducted in 2017].

A few last questions I wanted to ask you. I'm always interested in unrealized projects, because we know a lot about architects' unrealized projects, but we don't know much about artists' unrealized projects. What are your unrealized projects?

Yeah, I wanted to make a monument here in New York of renting—when the rentals were cheaper, renting a lot here in SoHo—and build a monument with arches of heads, you know, like a little park, uh, pyramid of heads.

Beautiful. Did you make drawings for that?

No, but the things are running around in my head all of the time, which I never, you know—every now and then I'm laying back, oh boy, it would have been nice. I even had the lot picked out. I didn't ask them how much, but it was between two loft buildings, you know. When things were very cheap here.

I have images in my head, now.

But you never drew it.

No, I never drew it, or made the studies for it, no. Because I knew it would never be realized, I didn't have the funds, or ...

How do you see Chicago, now? Have you been there recently?

I have no idea what's going on there. And I'm not in touch. Most of my friends have died, my peers have died.

Now, what would be your advice to a young artist?

Don't do it, man [*laughter*]. Unless you have income, don't do it. It's too rough. No, I'm making a joke. I don't know what I'd say to a young artist. You see, I've been so disconnected from the art world, especially here in New York. I felt once I do the work, the work has to speak for itself. Of course, in this commercial world, it doesn't work that way. I would have been a made artist, if I promoted myself and had gone to openings, you know, did all of the stuff you're supposed to do. But I didn't do any of that.

Gerhard Richter says art is the highest form of hope. What is art for you? Do you have a definition for art?

I don't think in those terms. I'm not anti-intellectual, I just don't intellectualize about most of these things, you know. All I can say is, you know, I had to be an artist. I don't know what drove me there, what pushed me in that direction, except for that incident I told you about, and the encouragement in public schools, for my drawings, you know,

paintings of heads and all that. Which is, in a way, one of the reasons I became so interested in Dubuffet—not that my heads were gross, like his—but here I was doing them as a young high school kid, or even younger, before, you know, I saw a guy who legitimized my, my whole life of making heads.

So there was a necessity to do it, you had to do it.

Right, I was driven to do it. Mainly because it was something I could do and I got encouragement and respect for it.

I just want you to describe for me again this unrealized project, for me to understand better. It's the most exciting thing for me of the whole interview, your unrealized project.

Yeah, well they would be life-size, my gaping heads, you know, that are in a lot of my work. . . . Not quite skulls, and not quite heads, in between. With open mouths and socket eyes.

And what would you have done with these gaping heads?

They would be turned into architectural elements, like arches that you could walk through, or pyramids of piles of these heads, or, uh, benches that you could sit on, made of heads, but just a garden, a sort of a—what you call that art of so-called primitive people—outsider. Like an outsider art thing. Just . . .

Beautiful.

Just an environment of my heads in architectural forms, like a garden.

This was an amazing interview, thank you very, very much.

Biographies

Fatimah Asghar

Fatimah Asghar is a nationally touring poet, performer, educator, and writer. Her debut collection of poems, *If They Come For Us*, was released via One World/Random House in August 2018, and her chapbook *After* was released by Yes Yes Books in 2015. Her work has been featured in *Poetry*, BuzzFeed Reader, the Academy of American Poets, PBS, NBC, *Teen Vogue*, Huffington Post, and many other outlets. She is the writer of *Brown Girls*, an Emmy-nominated web series that highlights a friendship between women of color. In 2017 she was the recipient of a Ruth Lilly and Dorothy Sargent Rosenberg Fellowship from the Poetry Foundation and was on the Forbes 30 Under 30 list. In 2011 she created REFLEKS, a Spoken Word Poetry group in Bosnia and Herzegovina, while on a Fulbright studying theater in post-genocidal countries. She is a member of the Dark Noise Collective and a Kundiman Fellow.

Louise Bernard

Louise Bernard is the founding director of the Museum of the Obama Presidential Center. She was formerly director of exhibitions at the New York Public Library. As a senior content developer and interpretive planner in the New York office of the museum design firm Ralph Appelbaum Associates, she worked on the design team that developed the Smithsonian Institution's National Museum of African American History and Culture, along with other international projects. She previously served as curator of prose and drama for the Yale Collection of American Literature at the Beinecke Rare Book and Manuscript Library at Yale, and as assistant professor of English at Georgetown University. She received her PhD in African American studies and American studies from Yale, and her current research engages with the literary archive, material culture, museology, public history, and interpretive planning and design.

Dawoud Bey

Dawoud Bey began his career as an artist in 1975 with a series of photographs, *Harlem, USA*. His works are included in the permanent collections of over fifty museums throughout the United States and Europe. Bey's recent work has turned to the visualization of the African American past, making that history resonant in the contemporary moment.

Bey is the recipient of a 2017 John D. and Catherine T. MacArthur Foundation Fellowship, the "genius grant." He was also the recipient of fellowships from United States Artists, the John Simon Guggenheim Memorial Foundation, and the National Endowment for the Arts, among other honors. Dawoud Bey holds an MFA from Yale University School of Art, and is currently professor of art and a former Distinguished College Artist at Columbia College Chicago, where he has taught since 1998. In 2018 a major forty-year retrospective publication, *Dawoud Bey: Seeing Deeply*, was published by the University of Texas Press.

Eula Biss

Eula Biss is the author, most recently, of *On Immunity: An Inoculation*, which was named one of the 10 Best Books of 2014 by the *New York Times Book Review*. Her second book, *Notes from No Man's Land: American Essays*, won the National Book Critics Circle Award for criticism in 2010. Her first book, *The Balloonists*, was published by Hanging Loose Press in 2002. Her writing has been supported by a Guggenheim Fellowship, a Howard Foundation Fellowship, a National Endowment for the Arts Literature Fellowship, and a Jaffe Writers' Award. She holds a BA in non-fiction writing from Hampshire College and an MFA in non-fiction writing from the University of Iowa. Her essays have recently appeared in *The Believer*, *Harper's*, and the *New York Times Magazine*.

Eddie Bocanegra

As senior director of READI Chicago at Heartland Alliance, Eddie Bocanegra oversees the evidence-based and trauma-informed program to reduce gun violence and promote safety and opportunity. A pioneer in the field, Bocanegra brings years of experience in programs created to address trauma and build resiliency among those most impacted by violence. He was previously executive director for the YMCA of Chicago, where he was responsible for programs that focused on trauma-informed approaches. He was the congregational organizer for Community Renewal Society, where he led FORCE (Fighting to Overcome Records and Create Equality), a coalition that advocates for increased opportunities for the formerly incarcerated. He also worked as a violence interrupter for Chicago's Ceasefire and was featured in the award-winning documentary *The Interrupters*. Bocanegra holds degrees in social work from the University of Chicago and Northeastern Illinois University. He has served on Chicago mayor Rahm Emanuel's Commission for a Safer Chicago, is a committee member of the Juvenile Justice Leadership Council, and is a board member of the Community Renewal Society and of the Juvenile Justice Initiative. He has spoken at the United Nations, the US Centers for Disease Control, and the US embassies in Spain and Uganda.

Brandon Breaux

Brandon Breaux is an American artist born in Chicago, whose work focuses on identity, the subconscious mind, and the fragility of the human psyche. His primary medium is oil paint, and he occasionally uses video, digital illustration, animation, and fashion in his works. With the overall goal of inspiring and educating his audience, Breaux uses symbolism to tell a larger story. Breaux is widely known as the artist behind Chance the Rapper's iconic album covers.

Shani Crowe

Shani Crowe is an interdisciplinary artist who received her BFA in film production from Howard University's John H. Johnson School of Communications in 2011. Her work centers on cultural coiffure, adornment, and beauty ritual as they relate to the diasporic African, and how these practices function as tools to foster connectivity. She is best known for creating intricate cornrow hairstyles, then capturing them as large photographic portraits. Shani's work was part of the ensemble selected to represent the United States in the Venice Architecture Biennale. Her work and performances have been featured at the Broad in Los Angeles; the Museum of Contemporary African and Diasporan Art (MoCADA) in Brooklyn, NY; the Urban Institute of Contemporary Art in Grand Rapids, MI; Columbia University; and Soho House, Chicago; and on *Saturday Night Live* in collaboration with Solange Knowles. She lives and works on Chicago's South Side.

Alison Cuddy

Alison Cuddy is Marilynn Thoma Artistic Director for the Chicago Humanities Festival (CHF), for which she sets the creative direction, developing some 140 programs annually, and directs Humanities Without Walls, a Mellon-funded career development workshop for humanities PhDs from across the country. She brings more than fifteen years of experience developing humanities programming for diverse publics, including ten years at WBEZ 91.5 FM, the NPR affiliate in Chicago. There she gained a national profile as the host of the award-winning program *Eight Forty-Eight* and helped launch *Odyssey*, a nationally syndicated talk show of arts and ideas, supported by the National Endowment for the Humanities.

In addition to her work at CHF, Cuddy moderates public forums in partnership with many of the city's cultural institutions and community organizations, including the Gene Siskel Film Center, the Museum of Contemporary Art, the Illinois Holocaust Museum, and Chicago Shakespeare Theater. Originally from Winnipeg, Manitoba, Cuddy moved to Chicago in 1999. She holds an MA in English from the University of Pittsburgh and a BA in cinema studies from Concordia University in Montreal.

She is a member of the Arts Club of Chicago, serves on advisory committees at the Terra Foundation for American Art and the Chicago Community Trust, and is a member of the advisory board at the Chicago Film Archives. She joined CHF in 2014.

Dominick Di Meo

An inspiration to subsequent artists, including Jim Nutt, Gladys Nilsson, and Art Green, Dominick Di Meo is one of Chicago's key transitional figures and an artist of immense power and sensitivity. One of the original members of the so-called Monster Roster, a 1950s group of Chicago artists that included Leon Golub, Nancy Spero, Cosmo Campoli, George Cohen, June Leaf, Ted Halkin, and Seymour Rosofsky, Di Meo's Chicago-era work was ferociously unique and personal.

His early paintings and drawings featured stressed, existentially tormented figures. He was deeply moved by his encounters with the catacombs of Mexico and Rome, and his dark, haunting images began to acquire a set of common icons, which included skulls and disarticulated limbs and bones. By the late 1950s Di Meo was making reliefs, utilizing papier-mâché, plastic, wood, layers of vinyl, and plaster. In 1961 he spent a year in Italy, traveling, living in Florence, and working feverishly on his reliefs.

When he returned to Chicago, he began painting on a larger scale, creating a stunning series of works that combine synthetic polymer and various methods of stenciling. Playful and somewhat lighter in tone, but still possessed of a dark sense of humor, these works were the last Di Meo showed during his tenure in Chicago.

Eve L. Ewing

Eve L. Ewing is a writer and a sociologist at the University of Chicago School of Social Service Administration. Dr. Ewing's work has appeared in the *New Yorker*, *Poetry*, *The Nation*, and the *New Republic*. She is the author of three books: the poetry collections *1919* and *Electric Arches*, and the nonfiction *Ghosts in the Schoolyard: Racism and School Closings on Chicago's South Side*. She also writes for Marvel Comics.

Jeanne Gang

Architect and MacArthur Fellow Jeanne Gang is the founding principal of Studio Gang, an architecture and urban design practice headquartered in Chicago with offices in New York, San Francisco, and Paris. Jeanne is recognized internationally for a design process that foregrounds the relationships between individuals, communities, and environments. Her analytical and creative approach has produced some of today's most innovative architecture, including the Arcus Center for Social Justice Leadership at Michigan's Kalamazoo College; Writers Theatre, a professional theater in Glencoe, Illinois; and the eighty-two-story Aqua Tower in downtown Chicago. Her current projects include the expansion of the American Museum of Natural History in New York City; the new United States embassy in Brasília, Brazil; and the University of Chicago's Center in Paris. Jeanne is the author of three books, and her work has been published and exhibited widely at venues such as the International Venice Architecture Biennale, MoMA, and the Art Institute of Chicago. She teaches architecture as a professor in practice at the Harvard Graduate School of Design, her alma mater.

Theaster Gates

Theaster Gates lives and works in Chicago. Gates creates work that focuses on space theory and land development, sculpture, and performance. Drawing on his interest and training in urban planning and preservation, Gates redeems spaces that have been left behind.

Known for his recirculation of art-world capital, Gates creates work that focuses on the possibility of the "life within things." Gates smartly upturns art values, land values, and human values. In all aspects of his work, he contends with the notion of black space as a formal exercise—one defined by collective desire, artistic agency, and the tactics of a pragmatist.

Gates has exhibited and performed at Sprengel Museum Hannover (2018); Kunstmuseum Basel (2018); National Gallery of Art, Washington, DC (2017); Art Gallery of Ontario (2016); Fondazione Prada, Milan (2016); Whitechapel Gallery, London (2013); Punta della Dogana, Venice (2013); and documenta (13), Kassel, Germany (2012). He was the winner of the Artes Mundi 6 prize and was a recipient of the Légion d'Honneur in 2017. He was recently awarded the Nasher Prize for Sculpture (2018).

Art Green

Art Green left Fort Wayne, Indiana, in 1960 to study at the School of the Art Institute of Chicago, and six years later, he and five other young graduates first exhibited as the Hairy Who at the Hyde Park Art Center. He has had twenty-nine solo exhibitions of his works, which are included in the collections of the Art Institute of Chicago, Chicago's Museum of Contemporary Art, and the Smart Museum of Art at the University of Chicago, among others.

Joseph Grigely

Joseph Grigely is an artist and writer, and director of the Hans Ulrich Obrist archive of publications and publication projects in Chicago. He has had solo exhibitions at the Whitney Museum of American Art; the Museum of Contemporary Art Chicago; the Musée d'art Moderne, Paris; the Douglas Hyde Gallery, Dublin; and the Whitney, Venice, Berlin, Istanbul, and Sydney Biennials.

Richard Hunt

Born in Chicago in 1935, Richard Hunt developed an interest in art at an early age. From seventh grade on he attended the Junior School of the School of the Art Institute of Chicago (SAIC). He went on to study there at the college level, receiving a BAE in 1957. A traveling fellowship from the School of the Art Institute took him to England, France, Spain, and Italy the following year. While still a student at SAIC, he began exhibiting his sculpture nationwide, and during his junior year one of his pieces, *Arachne*, was purchased by the Museum of Modern Art in New York. In 1962 he was the youngest artist to exhibit at the Seattle World's Fair.

In 1967 Hunt received his first large-scale public sculpture commission, *Play* (the first sculpture commissioned by the State of Illinois Public Art Program). This piece marked the beginning of what Hunt refers to as "his second career," a career that gives him the opportunity to work on sculpture that responds to the specifics of architectural or other designed spaces and the dynamics of diverse communities and interests. Since that time he has created over 150 commissioned works.

Hunt has received honors and recognition throughout his career and in 1971 was the first African American sculptor to have a major solo exhibition at the Museum of Modern Art in New York. His work can be found in numerous museums as well as both public and private collections, including the Art Institute of Chicago; the National Gallery and the Smithsonian American Art Museum in Washington, DC; and the Whitney Museum of American Art, the Metropolitan Museum of Art, and the Museum of Modern Art in New York. In 1968 he was appointed by President Lyndon Johnson as one of the first artists to serve on the National Council on the Arts, the governing board of the National Endowment for the Arts. Hunt has received many fellowships, prizes, and awards and holds sixteen honorary degrees from universities around the US, as well as memberships in the American Academy of Arts and Letters and the National Academy of Design. In 2009 Hunt was awarded the Lifetime Achievement Award by the International Sculpture Center, and in 2015 he received the Lifetime Achievement Award from Partners for Livable Communities in Washington, DC. In 2016 his thirty-by-thirty-foot welded-bronze sculpture *Swing Low* was installed in the Central Hall ceiling of the new National Museum of African American History and Culture at the Smithsonian Institution in Washington, DC.

Barbara Kasten

Barbara Kasten was born in 1936 in Chicago, Illinois. She received her BFA from the University of Arizona in 1959 and an MFA from the California College of Arts and Crafts in 1970. She currently lives and works in Chicago. She is a John Simon Guggenheim Fellow, National Endowment for the Arts grant recipient, and a Fulbright-Hays Fellow. In 2015 her survey exhibition *Barbara Kasten: Stages* originated at the Institute of Contemporary Art in Philadelphia, then traveled to the Graham Foundation in Chicago and MoCA in Los Angeles. Her work has been featured globally, including in the Sharjah Biennial 14, United Arab Emirates; Tate Modern, London; Museum of Modern Art, Frankfurt, Germany; Tokyo Metro Museum of Photography, Tokyo; Museum of Modern Art, Whitney Museum of American Art, and Guggenheim Museum, New York; and Smithsonian American Art Museum, Washington, DC; among many others.

Ricky Murray

Ricky Murray was born in Little Rock, Arkansas, and moved to Chicago in 1936. He is a vocalist who sang with Sun Ra & His Arkestra from 1959 to 1962, performing such songs as "Dreamville," "Early Autumn," and "I Struck a Match on the Moon." He currently performs with the Mudcats, who specialize in New Orleans jazz and blues.

Hans Ulrich Obrist

Hans Ulrich Obrist was born in Zurich, Switzerland, and is artistic director of the Serpentine Galleries, London. Previously, he was the curator of the Musée d'Art Moderne de la Ville de Paris. Since his first show, *World Soup (The Kitchen Show)*, in 1991, he has curated more than three hundred exhibitions. In 2011 Obrist received the CCS Bard Award for Curatorial Excellence, and in 2015 he was awarded the International Folkwang Prize for his commitment to the arts. Obrist has lectured internationally at academic and art institutions, and is a contributing editor to several magazines and journals. His recent publications include *Conversations in Mexico*, *Ways of Curating*, *The Age of Earthquakes* (with Douglas Coupland and Shumon Basar), and *Lives of the Artists, Lives of the Architects*. Ignited by his fascination with the artist interview as art itself, Obrist began "The Interview Project," a lifelong project featuring lengthy conversations with artists, architects, writers, filmmakers, scientists, philosophers, musicians, performers, and other cultural figures. Interviews from this project have been recorded and published in *Artforum*, and in a series of books.

Suellen Rocca

Suellen Rocca is an artist known as a Chicago Imagist and a member of the artist collective the Hairy Who. Her works have been widely exhibited and are in many prestigious collections, including, in Chicago, the Art Institute, Museum of Contemporary Art, David and Alfred Smart Museum, and DePaul Art Museum, and, in Philadelphia, the Philadelphia Art Museum and Pennsylvania Academy of Fine Arts. At Elmhurst College, Rocca is the curator of an internationally known Imagist art collection, serves as director of exhibitions, and teaches in the art department.

Tim Samuelson

Tim Samuelson has been seeking out the stories of Chicago's past for over forty years. As the city's official cultural historian, he believes that history goes beyond good scholarship and careful footnotes—if history is to be vital and relevant, telling the story engagingly is equally important. And if it can be fun, so much the better! Samuelson has told Chicago's many stories through well-received exhibits, books, public programs, and media presentations. Topics include the city's wide-ranging contributions to art and culture, with a special focus on architecture and music.

Cauleen Smith

An artist whose primary discipline is film, Smith has incorporated various influences and references in her images—science fiction, the black diaspora, and the lyrical potential of landscape. She first garnered national recognition with her feature-length film *Drylongso* (1998), which she completed during

her graduate training at UCLA's film school. In 2010 Smith moved to Chicago, where her work has grown increasingly site-specific and engaged in social activism. She created the Solar Flare Arkestral Marching Band Project, which has organized flash-mob appearances of a marching band composed of youth groups from the city's South Side. This and other recent works have explicitly invoked the legacy of pioneering composer and performer Sun Ra, whose music and elaborate self-defining mythology also propelled the broader artistic movement of Afrofuturism.

Edra Soto

Born in Puerto Rico, Edra Soto is a Chicago-based interdisciplinary artist, educator, curator, and codirector of the outdoor project space The Franklin. She is invested in providing visual and educational models propelled by empathy and generosity. Her recent projects, which are motivated by civic and social actions, focus on fostering relationships with a wide range of communities. Recent venues presenting Soto's work include the Chicago Cultural Center, Museo de Arte de Puerto Rico, Nerman Museum of Contemporary Art (KS), Pérez Art Museum Miami (FL), Hunter East Harlem Gallery (NY), University of Illinois at Chicago Gallery 400, Bemis Center for Contemporary Art (NE), and the Museum of Contemporary Art in Chicago. Soto has attended residency programs at Skowhegan School of Painting and Sculpture (ME), Beta-Local (PR), the Robert Rauschenberg Foundation Residency (FL), Headlands Center for the Arts (CA), Art OMI (NY), Project Row Houses (TX), and Arts/Industry at the Kohler Foundation (WI), among others. Recent commissions include a two-year exhibition at Millennium Park in Chicago and a collaborative project with Dan Sullivan for the Chicago Transit Authority. In 2017 Soto was awarded the Efroymson Contemporary Arts Fellowship for installation artists. Her co-curation for the exhibition *Present Standard* at the Chicago Cultural Center was praised by the *Chicago Tribune*, *Newcity*, *The Art Assignment* (PBS), and *Artforum*. Soto has been featured in *Newcity*'s "Art 50" issue ("Chicago's Artists' Artists") and at VAM Studio 2017 Influencers. Soto teaches at the University of Illinois at Chicago and is a lecturer for the Contemporary Practices Department at the School of the Art Institute of Chicago, from which she received an MFA. She holds a BFA degree from Escuela de Artes Plastics de Puerto Rico.

Stanley Tigerman

Stanley Tigerman, who was a principal in the Chicago architectural and design firm Tigerman McCurry Architects, received both his architectural degrees from Yale University. Of the four hundred-plus projects defining his career, 185 built works embrace virtually every building type. He designed projects throughout North America, Europe, and Asia and was the recipient of design awards from the American Institute of Architects (AIA), the Chicago and Illinois AIA chapters, as well as Architectural Record Houses and Interiors and the PA Design Awards. Tigerman was one of the architects selected to represent the United States at the 1976, 1980, and 2012 Venice Biennales, and was featured in the 2015 and 2017 Chicago Architecture Biennials. He was an author, lecturer, and visiting chaired professor at numerous universities, including Yale and Harvard; served as director of the UIC School of Architecture for eight years; and cofounded ARCHEWORKS, a socially oriented design laboratory and school. Tigerman was a founding member of the Chicago Seven as well as the Chicago Architectural Club, and received Yale University's first Alumni Arts Award. He received the Illinois Academy of Fine Arts Award and was the recipient of the American Jewish Committee's Cultural Achievement Award. Additional honors include the International Union of Bricklayers and Allied Craftworkers Louis Sullivan Award; the AIA/ACSA Topaz Medallion for Excellence in Architectural Education; the AIA Illinois Gold Medal in recognition of outstanding lifetime service; and lifetime achievement awards from the Architecture and Design Society of the Art Institute of Chicago and the Chicago chapter of the AIA. The author of six books and editor of eight, his last is his autobiography, *Designing Bridges to Burn*.

Amanda Williams

Amanda Williams is a visual artist who trained as
an architect. Her creative practice navigates the
space between art and architecture, through works
that employ color as a way to highlight the political
complexities of race, place, and value in cities.
Williams has received critical acclaim, includ-
ing being named a USA Ford Fellow and a Joan
Mitchell Foundation grantee. Her works have been
exhibited widely and are included in the perma-
nent collections of the Art Institute of Chicago and
the Museum of Modern Art in New York. She lives
and works on the South Side of Chicago.

Gerald Williams

Gerald Williams is a painter and founding member
of AfriCOBRA (African Commune of Bad Relevant
Artists), an African American artist collective.
He earned an MFA at Howard University, served
in the United States Air Force, was a Peace Corps
volunteer for several years, taught in public schools
in Chicago and Washington, DC, and served as
arts and crafts director for the United States Air
Force for twenty years until his retirement in 2004.

Acknowledgments

We, Hans Ulrich Obrist and Alison Cuddy, express our deepest appreciation to editors Maggie Taft and Joel Score, designer James Goggin, and all those organizations and individuals who made *Creative Chicago: An Interview Marathon* and this publication possible.

The marathon's development was informed by the wise counsel of an advisory committee. We thank members Nora Daley, Susanne Ghez, Paul Gray, Joseph Grigely, Steve Koch, Linda Johnson Rice, and Walter Massey for their insights and advice.

Our deepest gratitude goes to the *Creative Chicago* participants and their teams, including Fatimah Asghar, Sarah Coakley, and Royal Scales; Louise Bernard and Sophie Lloyd; Dawoud Bey; Eula Biss, Kate Dublinski, and Matt McGowan; Eddie Bocanegra, Jane Bodmer, and Jane Manwarring; Brandon Breaux; Shani Crowe; Dominick Di Meo, John Corbett, Jim Dempsey, and Kate Pollasch; Eve L. Ewing; Jeanne Gang, Alissa Anderson, Susan Bell, and Josh Ellman; Theaster Gates and Mallory McClaire; Art Green; Joseph Grigely and Katy Snow Niner; Richard Hunt and Lynne Brown; Barbara Kasten; Ricky Murray and Tim Burns; Suellen Rocca; Tim Samuelson; Cauleen Smith; Edra Soto; Stanley Tigerman, Margaret McCurry, and Nathaniel Parks; Amanda Williams and Bianca Marks; and Gerald Williams.

We wish to thank the staff of the Chicago Humanities Festival for producing and promoting the event. We are especially grateful to Phillip Bahar, Tiffanie Beatty, Shanna Brown, Olivia Cunningham, Natalie Edwards, Joe Engleman, Kristen Fallica, Mira Hayward, Brenda Hernandez, Emily Kober, Eddie Medrano, Bill Melamed, Emmett Mottl, Kelly Murphy, Brittany Pyle, Alexandra Quinn, Rina Ranalli, Jason Saldanha, and Travis Whitlock. Additional thanks to Amy Walsh.

Creative Chicago: An Interview Marathon and this publication would not have been possible without the support and leadership of the Terra Foundation for American Art. We thank the Terra Foundation's Art Design Chicago team: Elizabeth Glassman, Amy Zinck, Anne Cullen, Maureen Jasculca, Charles Mutscheller, Joe Shansky, Jennifer Siegenthaler, and Eva Silverman, as well as Francesca Rose and Rebecca Park.

Our hosts and partners at EXPO CHICAGO, including Tony Karman, Stephanie Cristello, Chloe Cucinotta, and Kathleen Rapp, as well as the team at Navy Pier, including Michelle T. Boone and Dylan Hankey, were instrumental in the planning and execution of the marathon.

We would also like to express appreciation to the Serpentine Galleries, particularly Yana Peel, Lucia Pietroiusti, Claude Adjil, Laura Macfarlane, and Laura Norman, and to Hans Ulrich Obrist's team, Max Shackleton and Lorraine Two Testro.

Numerous other organizations and individuals contributed to the development and realization of *Creative Chicago: An Interview Marathon* and this publication. In particular, we want to recognize Mark Kelly, Jamey Lundblad, and Sue Vopicka of the Chicago Department of Cultural Affairs and Special Events; Lauren Davis, Carol Fox, Nick Harkin, Francesca Kielb, Alyssa Larkin, and Carly Leviton of Carol Fox & Associates; Carrie Olivia Adams, Susan Bielstein, Steven Pazik, Levi Stahl, and James Toftness of the University of Chicago Press; Jon Shaft; and the teams at Caption Access, the Chicago History Museum, Digital Café, *Newcity*, Spirit of Space, the Studs Terkel Radio Archive, and WFMT.

Credits

Event photographs throughout by David T. Kindler, courtesy of Chicago Humanities Festival. Stage installation courtesy of Barbara Kasten and Bortolami, NY; Kadel Willborn Gallery, Düsseldorf; Thomas Dane Gallery, London. © 2019 Barbara Kasten. Studs Terkel archival clips courtesy of Chicago History Museum, WFMT, and the Studs Terkel Radio Archive.

33, 36: Courtesy of Tim Samuelson; **44:** Cover art by Amy Reeder; **46:** Haymarket Books. Photograph by Lauren Miller; **53:** Photograph by Glenn Smith; **55:** *A Visitor's Guide to the Hans Ulrich Obrist Archive*. Chicago: The Hans Ulrich Obrist Archive, 2018; **56:** Photograph by Nathan Keay, © MCA Chicago; **60:** Courtesy of AfriCOBRA and Kavi Gupta; **61, 68, 70:** Photograph © 2019 courtesy of The David and Alfred Smart Museum, The University of Chicago; **75:** Courtesy of Stanley Tigerman; **76:** Photograph by Howard N. Kaplan, HNK Architectural Photography; **77:** Photograph by Balthazar Korab, courtesy of the Library of Congress; **78:** Photograph by David Seide, courtesy of Illinois Holocaust Museum; **81:** Photograph courtesy of Otto E. Wieghardt; **82:** Photograph courtesy of Richard Hunt; **85:** Chicago Public Art Collection. Photograph courtesy of Richard Hunt; **94:** Courtesy of Barbara Kasten and Bortolami, New York; Kadel Willborn Gallery, Düsseldorf; Thomas Dane Gallery, London; **95:** Courtesy of Barbara Kasten and Bortolami, New York; Kade Willborn Gallery, Düsseldorf; Thomas Dane Gallery, London. Photograph: RCH | EKH; **97:** Photograph © Studio Gang;

98: Photograph © Spirit of Space; **99:** Photograph by Steve Hall, © Hall + Merrick; **104:** Photograph courtesy of Edra Soto; **105:** Photograph by James Prinz; **106:** Photograph by JASSIEUO; **113, 114:** Photograph courtesy of The Obama Foundation; **118:** Photograph by Tom Harris, © Hedrich Blessing, courtesy of Rebuild Foundation; **119:** Photograph courtesy of Rebuild Foundation; **120:** Photograph by Nancy Wong; **124, 126, 127:** © Dawoud Bey, courtesy of Dawoud Bey and Stephen Daiter Gallery; **141:** Photograph courtesy of Shani Crowe; **142:** Photograph courtesy of Refinery 29; **145:** Photograph courtesy of Heartland Alliance; **150:** Photograph by Tom Harris, courtesy of the School of the Art Institute of Chicago and the University of Chicago; **152:** Photograph courtesy of Amanda Williams; **160:** Image courtesy of Cauleen Smith; **161:** Photograph courtesy of Cauleen Smith; **162:** Image courtesy of Brandon Breaux; **164:** Photograph courtesy of Brandon Breaux; **170, 172, 174:** Courtesy of Dominick Di Meo and Corbett vs. Dempsey, Chicago.

About the Terra Foundation for American Art

The Terra Foundation for American Art is dedicated to fostering exploration, understanding, and enjoyment of the visual arts of the United States for national and international audiences. Recognizing the importance of experiencing original works of art, the foundation provides opportunities for interaction and study, beginning with the presentation and growth of its own art collection in Chicago. To further cross-cultural dialogue on American art, the foundation supports and collaborates on innovative exhibitions, research, and educational programs. Implicit in such activities is the belief that art has the potential both to distinguish cultures and to unite them.

For information on grants, programs, and publications at the Terra Foundation for American Art, visit terraamericanart.org.

TERRA
FOUNDATION FOR AMERICAN ART

Terra Foundation for American Art

Elizabeth Glassman, *President and Chief Executive Officer*
Amy Zinck, *Executive Vice President*
Anne Munsch, *Chief Financial Officer*

Jennifer Siegenthaler, *Program Director, Education Grants & Initiatives*
Eva Silverman, *Special Projects Developer*

Francesca Rose, *Program Director, Publications*
Rebecca Park, *Program Associate, Publications*

**Creative Chicago:
An Interview Marathon**
Hans Ulrich Obrist & Alison Cuddy

Eva Silverman, *Project Manager*
James Goggin, Practise, *Designer*
Maggie Taft, *Content Editor*
Joel Score, *Copy Editor*
Pamela Glintenkamp, *Transcriber*
David T. Kindler, *Photographer*

Cover
Barbara Kasten. *Intervention*, 2018. Steel and fluorescent acrylic, 9.5 × 14 × 4.5 ft. Courtesy of the artist and Bortolami, NY; Kadel Willborn Gallery, Düsseldorf; Thomas Dane Gallery, London. © 2019 Barbara Kasten.

Published by the Terra Foundation for American Art, 120 East Erie Street, Chicago, Illinois, 60611, United States
terraamericanart.org

Typeset in LL Bradford
 (Laurenz Brunner, Lineto, 2018)
Lithography by Colour & Books, Netherlands
Printed by Wilco Art Books, Netherlands
Binding by Epping Boekbinders, Netherlands
Distributed by University of Chicago Press

ISBN 978-0-932171-67-2 (paperback)

Library of Congress Cataloging-in-Publication Data

Names: Obrist, Hans Ulrich, interviewer. | Cuddy, Alison. | Ewing, Eve L., interviewee. | Samuelson, Tim, interviewee. | Terkel, Studs, 1912–2008, interviewee.
Title: Creative Chicago : an interview marathon / Hans Ulrich Obrist & Alison Cuddy ; with Tim Samuelson and Eve L. Ewing and Joseph Grigely and Gerald Williams, Suellen Rocca & Art Green and Stanley Tigerman and Richard Hunt and Barbara Kasten & Jeanne Gang and Edra Soto & Fatimah Asghar and Louise Bernard & Theaster Gates and Dawoud Bey and Shani Crowe & Eddie Bocanegra and Amanda Williams & Eula Biss and Cauleen Smith & Brandon Breaux and Dominick Di Meo.
Description: Chicago : Terra Foundation for American Art, [2019]
Identifiers: LCCN 2019023228 | ISBN 9780932171672 (paperback)
Subjects: LCSH: Arts, American—Illinois—Chicago—20th century. | Arts, American—Illinois—Chicago—21st century. | Artists—Illinois—Chicago—Interviews.
Classification: LCC NX511.C45 C74 2019 | DDC 700.9773/110904—dc23
LC record available at https://lccn.loc.gov/2019023228